Print, Pattern and Colour

for Paper and Fabric

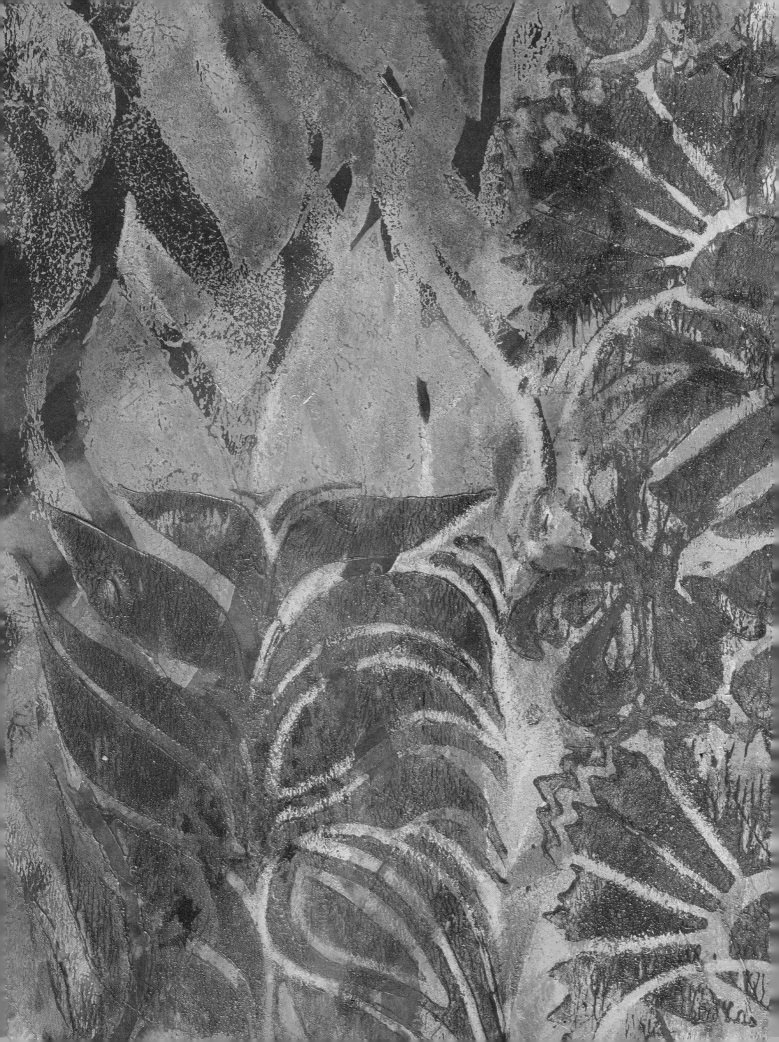

Print, Pattern and Colour
for Paper and Fabric

Ruth Issett

BATSFORD

This book is dedicated to everyone who has been kind enough to encourage me and has told me that they find these books helpful. It is also dedicated to my ever-loyal family who keep me up to speed and are always willing to give me a helping hand!

First published in the United Kingdom in 2007 by
Batsford
10 Southcombe Street
London W14 0RA

An imprint of Anova Books Company Ltd

ISBN-10: 0 7134 9037 3
ISBN-13: 9780 7134 9037 4

A CIP catalogue record for this book is available from the British Library.

15 14 13 12 10 09 08 07
10 9 8 7 6 5 4 3 2 1

Reproduction by Spectrum Colour Ltd, England
Printed by Craft Print Ltd, Singapore

This book can be ordered direct from the publisher at the website:
www.anovabooks.com
Or try your local bookshop

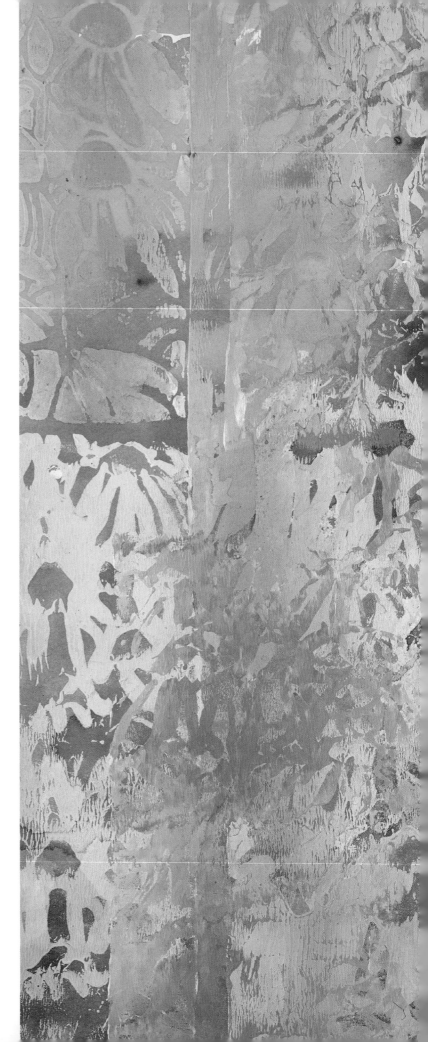

Page 2: Leaf and floral block print using acrylic inks.

Right: Block and roller print based on floral print work *A Floral Collection*, page 115.

Contents

Introduction

This book is for everyone who is attracted to the idea of creating printed papers and fabrics that feature glowing colours or exciting patterns. Perhaps you have been inspired to print by the sight of a beautiful natural landscape, or the vibrant tones of a field of poppies in paint. Filled with enthusiasm, you may have gone into art shops but then found the range of materials available quite overwhelming. If you long to feel more confident when choosing and mixing colours, and making them into prints, then this is the book for you.

Inside these pages you will find information on materials, printing mediums and equipment, and also on the various techniques you can try. Starting to make prints can be daunting, but with practice you will soon be making satisfying and attractive examples. Each time you print on a piece of paper or fabric you will gain more experience of the equipment and techniques that you are trying, and this will soon lead to new ideas.

This book introduces the various print techniques as well as many ideas and examples that you can explore and develop further. I will often draw on examples from my own design ideas but, as you become more confident, your ideas will reflect your taste, personality and experience. The beautiful prints that you make will be unique and special to you.

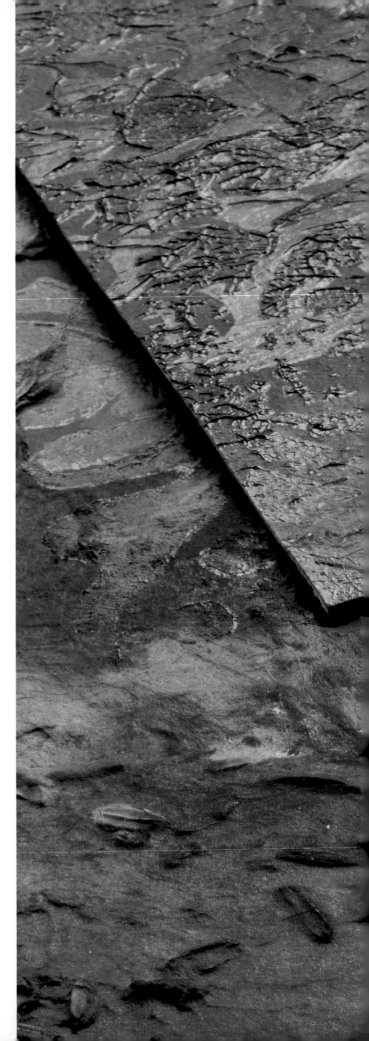

Right: Experimental pieces exploring the possibilities of a collection of blocks. Acrylic printing onto a variety of handmade papers.

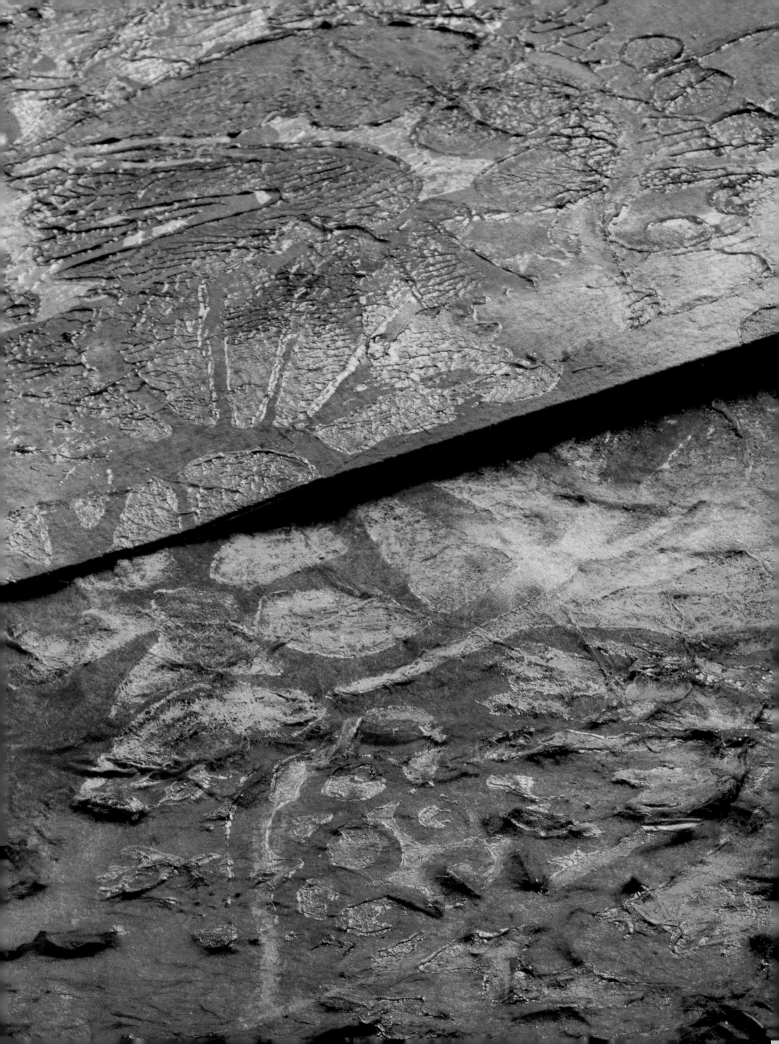

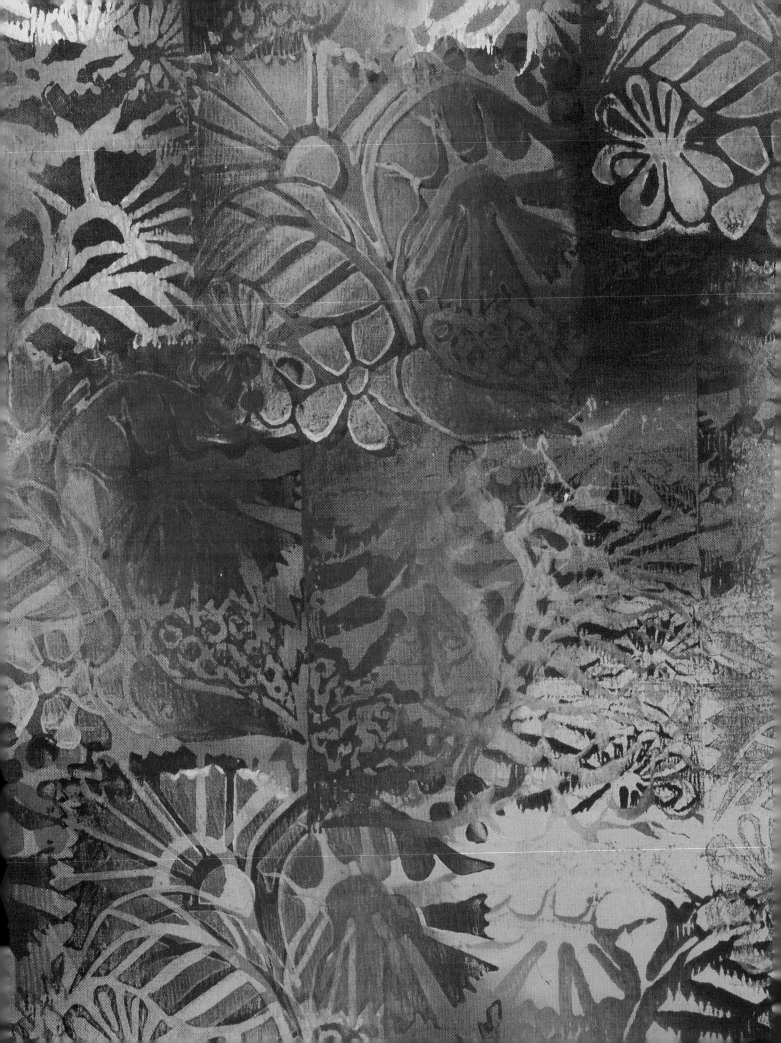

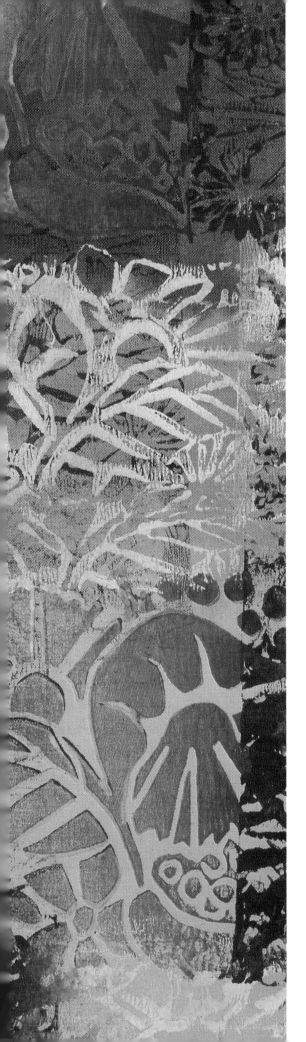

Chapter 1
Getting Started

Printing, in broad terms, is a technique whereby a print block or other printing sheet has liquid colour applied to it and then is pressed onto a second surface. This surface, which may be paper or fabric (or any other suitable surface, for that matter) forms the print. In order to create crisp, clear prints the surface onto which you are printing needs to be relatively smooth and capable of taking the paint or other colour. At the same time, the liquid colour needs to have the right consistency both to adhere to the print block (and also to the printing sheet or plate from which colour is transferred by roller or other means to the block) and to be released from it when it is applied to the smooth surface, be it paper or fabric. When making prints by hand, choosing the right tools and surfaces to achieve this process is important – but need not be complicated.

Left: Block and roller print using floral block,
printed with textile colour then overdyed.

WORKSPACE AND EQUIPMENT

Firstly, it is important to have a place to make prints. Printing can be undertaken successfully in a range of different workspaces, from a small board placed on a kitchen table to a specially designed print table that may be several metres long. You can adapt your workplace to what you have available, and indeed many enthusiastic textile printers 'make do' by using imaginative and creative solutions that enable them to produce exciting prints.

It is not essential to have a dedicated space. But you will find that once you start printing you will quickly produce many pieces of printed paper and fabric. You will need to allocate areas for your prints to dry, but space constrictions can easily be overcome by using a simple clothes line and pegs or a clothes-drying rack. It is essential to be well organized when printing because the processes are quick and it is easy to become very messy if you have not planned ahead. It is a good idea to organize a simple plastic tray for your printing equipment (such as print colour, paper towels, damp cloth or baby wipes) and to have newspaper at hand to protect surfaces. You will also need a sink available for washing equipment. If your working space is very restricted and a sink is not available you can purchase a shallow plant tray and use two buckets filled with water for 'dirty cleaning' and 'clean rinsing' – this works extremely well and has the added benefit of conserving water.

The following basic equipment is associated with different printing techniques. Initially you will only need some of the equipment. As you become more adventurous you will probably add more to your collection.

Many printing processes require a **print plate** or **sheet** on which the liquid colour is placed before being transferred to the print surface. For instance, a roller can be used to pick up colour from the plate, which is then rolled onto the surface of a print block. The block will then be applied to the paper or fabric. The printing plate needs to be non-absorbent, shiny and relatively sturdy, and can be made using something as simple as a square of stiff plastic or polythene. But, being slightly unstable, this is not necessarily the most satisfactory solution. However, it is an excellent choice when travelling and has the additional benefit of being inexpensive. The chart opposite lists a few surfaces that you could use as a print plate or sheet.

Right: Printing equipment: screens, squeegees, shapers, stencils, tile grouters, brushes and sponge brushes.

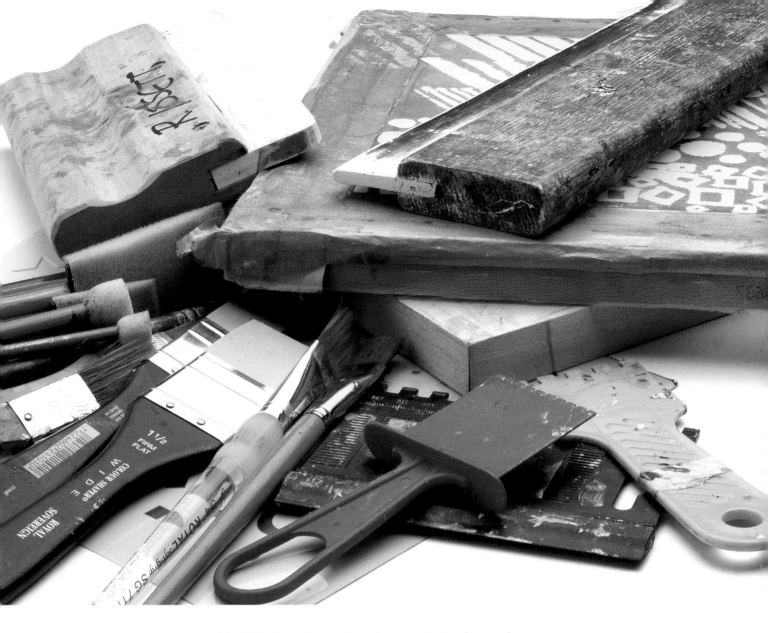

The following make good or adequate printing plates or sheets:

Equipment	Advantages/Disadvantages
Toughened glass sheet (with a ground edge for safety) – A4 or A3 size	Easy to handle and clean. Transparent, easy for print placement. Rather heavy, can chip and break and be dangerous.
Perspex	Easy to handle, lightweight. Transparent, easy for print placement. Less easy to clean, surface scratches.
Laminated sheets	Cheap, lightweight, easily replaced. Easy to clean, flexible.
Polypropylene sheet	Light, flexible, translucent, cheap.

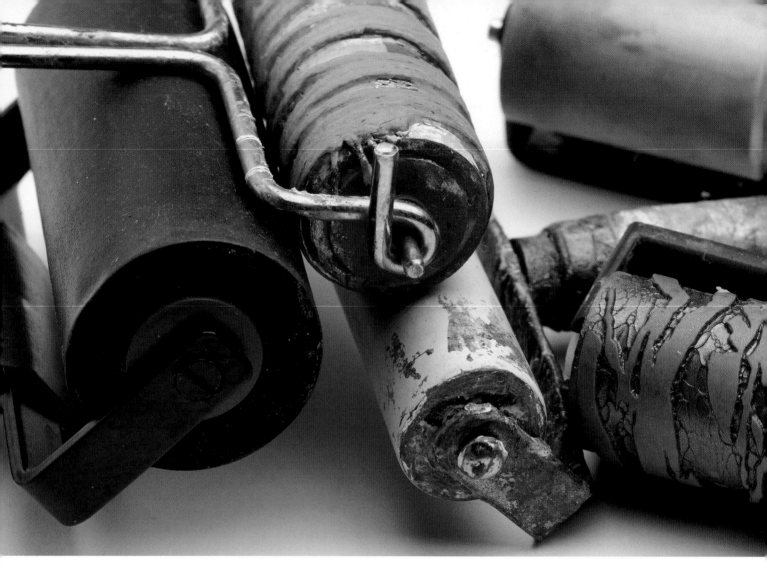

Shaper brushes are useful when drawing into print colour on a printing sheet. They have a soft rubber tip shaped as a chisel or point. Use them to draw lines and patterns into freshly applied print colour.

Grouting tools, available from DIY (home improvement) shops, are excellent for creating multiple lines when drawing into soft print colour and are available in different widths and spacing. You can use them to create strong flowing parallel lines as well as circles and rippling curves and swirls.

A **print roller** or **brayer** is almost essential in order to spread colour evenly onto the print plate or block (also called a stamp), although colour can also be spread on using a stiff brush. It is worth obtaining a good print roller because it speeds up the printing process and also gives you access to a wide and varied range of possibilities. Print rollers are available in different widths, materials and sizes. It is helpful to select the most suitable one for the type of printing that you are doing and for your personal requirements, and it may be useful to have several different rollers to give print variety in your work. (See the detailed list on the opposite page.)

See the section on Block Printing on page 26 in chapter 2 for more detailed information on using rollers with block prints.

Screens are wooden frames used for screen printing. They come in any size from about 25cm (10in) by 20cm (8in) up to 120cm (48in) by 60cm (24in), and are tightly stretched with a screen mesh that is very fine. They can be bought ready prepared.

Above: Print rollers. Left to right: medium-soft roller, string-covered roller, lino roller, soft rubber roller, patterned roller.

PRINT ROLLERS

Description of roller/brayer	Advantages/disadvantages
Simple lino/press roller with metal handle, with 'legs' which act as a stand. Available in three sizes: 30 x 120mm (1¼ x 4¾in), 30 x 90mm (1¼ x 3½in), 20 x 60mm (¾ x 2¾in).	Lightweight, easy to handle and well balanced. Very easy to clean and the simple construction prevents threads and different media from sticking to the roller surface.
Firm lino/press roller available in two sizes: 30 x 120mm (1¼ x 4¾in), 30 x 90mm (¾ x 3½in). Slightly more substantial construction with wooden handle. Simple stand in form of 'legs'.	Medium-weight, easy to handle and well-balanced. Slightly less easy to clean, especially if printing medium is allowed to dry.
Soft rubber rollers with plastic handles, such as those made by Speedball. Available in 50mm (2in), 80mm (3⅛in), 110mm (4¼in) and 150mm (6in) widths.	Slightly softer rollers. Good for printing detailed patterns. The plastic handle slightly changes the balance but is easy to handle.
Soft rubber roller with long metal shaft and wooden handle, 110mm (4¼in) wide.	A basic roller that does not have a stand. Sometimes the handle is too heavy, making the roller unbalanced.
Medium-soft, very dense (usually black) foam rollers with smooth surface – available in 100mm (4in) and 60mm (2¼in) width.	Unusual lightweight rollers, useful for offset prints. However, the surface easily becomes indented and must be thoroughly cleaned after use.
Fiskars patterned rollers, or similar – a handle with interchangeable patterned rollers	Quite fun but can be limited by the patterns available.
Sponge rollers – various widths, lightweight sponge.	Soft, so not really suitable for printing with blocks (stamps) but excellent for applying quantities of liquid such as dye or ink, or for large abstract textural surfaces.
Pattern sponge rollers: patterns include squares, ripples, stripes, wide waves.	Soft but fun for applying liquid colour such as inks, dyes, varnishes and fluid acrylic inks.

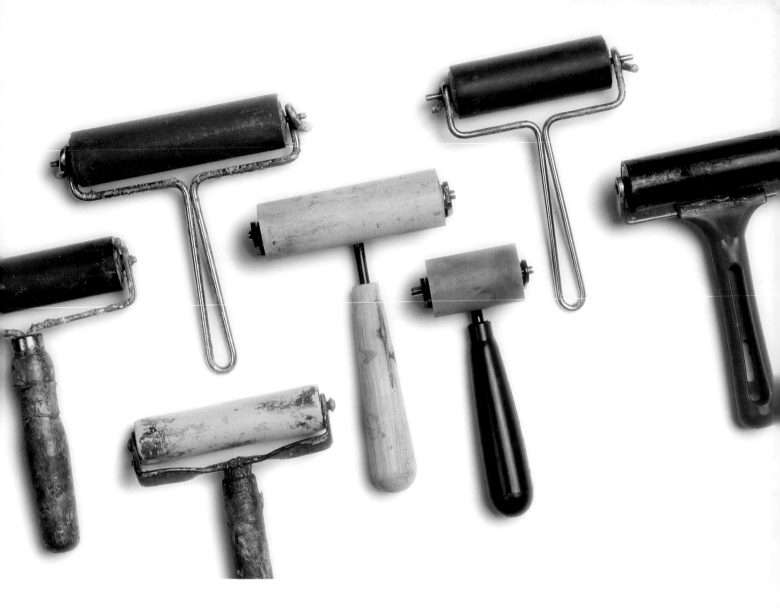

A **squeegee** is a wooden handle with a flexible rubber or polyester blade, used to press the paint through the screen when using screen-printing techniques. The width of the squeegee should easily fit inside the screen frame with about 2.5cm (1in) space on either side for easy movement. For fabric printing the blade needs to be short so that when the print colour is moved across the screen, in front of the blade, it is forced through the printing mesh onto the cloth below.

Both squeegees and blades can be bought from screen-printing suppliers and vary enormously in type and price. For fabric printing at home, invest in a comparatively small screen to start with, as this will be the most adaptable.

An **expanding sponge** comes as a thin flat sheet, varying from A6 (105 x 148mm/ 4⅛ x 5¾in) to A4 (210 x 297mm/8¼ x 11¾in) in size. Before it is expanded the sponge is easy to cut into simple shapes, either with scissors or a craft knife. Once cut and immersed in clean water, the sponge will expand in both depth and width. Allow it to dry before using it for printing with acrylic paint and in fabric printing.

Stencils come in numerous pre-cut designs, from basic shapes to intricate motifs. However, the simple geometric shapes such as spots, zigzags, honeycomb and ripples provide the greatest design flexibility. Available in a variety of sizes, they enable you to create detail within larger designs.

Above: Various print rollers, including lino rollers, firm lino roller with simple metal handle, soft rubber rollers with wooden handles and a soft rubber roller with plastic handle.

PRINT TOPS

Selecting the right surface to place *under* the paper or fabric on which you are going to be printing is almost as tricky as choosing the print medium itself, and it is important to use an appropriate surface or 'print top' under the print surface. For instance, when printing on fabric, use a slightly padded surface underneath the fabric (see chart below). This will help the print to impress into the fabric, giving a good clean print.

The covering for your work surface can be made using materials readily available at home, or you can make slightly more substantial surfaces that require a little investment.

Print Tops

Print Tops	Advantages/Disadvantages
Old blanket covered with an old sheet.	Works quite well for small pieces. Keep sheet flat, and wash it frequently.
Thick wooden board with either blanket or wadding stretched taut over whole worktop area. Stretch cover over this, made from thick calico (muslin).	This makes an excellent print top. Can be made to suit workspace, easily stored upright. Stretched surface is good for pinning fabric flat when printing multiple colours. Disadvantages – print top becomes covered with paint from previous prints.
Thick wooden board with either blanket or wadding stretched taut over whole worktop area. Cover work surface with stout plastic for easy cleaning.	Good flat print top for working on, although it is necessary to tape fabric to surface. Easy to clean. Can cause 'flooding' if print is too wet and bleeds through fabric onto plastic.
Thermal table protector – available by the metre to protect dining tables from heat.	The insulation provides a padded surface that often comes covered by a plastic coating. It can be easily stored rolled up, thus giving a quick and even print top to work on.

Chapter 2
Printing on Paper

This chapter introduces a range of common printing techniques, mostly introduced here in relation to printing on paper although they are also just as relevant to textile printing. Later on, in Chapter 3, many of these same techniques will be applied to printing on fabric, which sometimes requires different choices when it comes to mediums (colours and dyes), material and effective design decisions.

Right: Roller print using pattern from plastic canvas on paper, then inked.

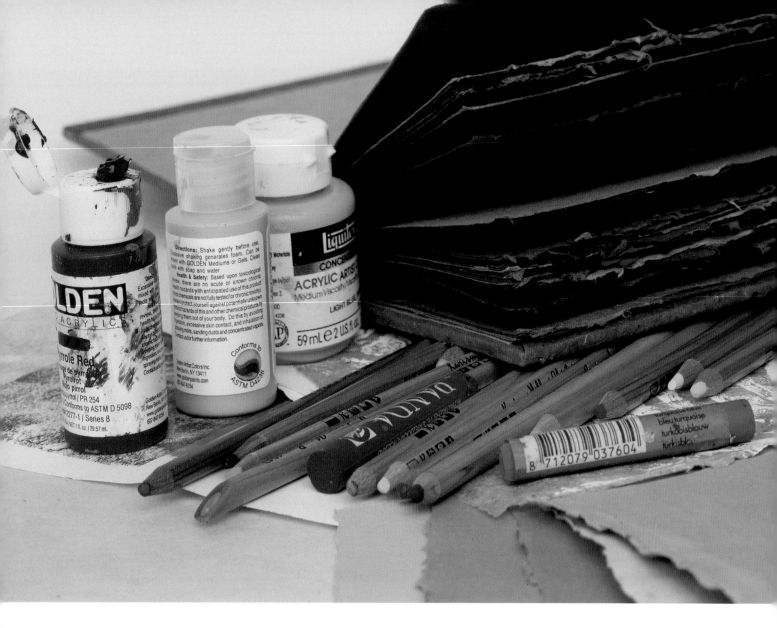

CHOOSING PAPERS

When selecting paper, always choose the best you can afford. A pad of premium-quality cartridge paper (110gsm) is useful for trying ideas and developing print techniques, while a collection of various everyday papers is invaluable to test prints and techniques. Accumulate white tissue paper, tracing paper, newsprint, brown wrapping paper (Kraft paper) and greaseproof paper. While these papers are designed for practical purposes that have nothing to do with printing, they are often good quality, strong when wet and have a smooth finish.

But also look at some more unusual papers. There are numerous handmade papers available at present. Papers made from banana, Kozo and Lokta as well as cotton rag and jute give a wide range of surfaces and weights. Choose lightweight Lokta papers from 30 to 100gsm, such as banana fibre, Tsasho and Resho. Or try a slightly weightier paper, a smooth cotton rag such as wool, algae or straw to give a more robust printed quality.

Try to avoid thin, cheap papers such as sugar paper or very lightweight cartridge paper as they just suck in all the printed colour and easily cockle (distort) when wet.

Above: Art materials – drawing equipment, pencils, papers (cartridge, coloured & natural Lokta, coloured Khadi, pastel paper, sketchbook, acrylic colours

MONO PRINTING

Mono printing is effectively a type of contact printing – that is, pressing painted and drawn patterns into a print surface to transfer the colour to the paper. The name monoprint refers to the fact that this technique produces only one, unique print and cannot be used to make duplicate prints (as with block printing or screen printing, for instance). Mono printing is worth exploring as a way of experimenting with patterns, textures and surface patterns, and it allows you a simple means to plan and try out ideas.

For mono printing on paper, use acrylic colour such as Rowney System 3, Winsor and Newton Galleria, Liquitex Concentrates or Golden tube colour. Golden Fluids tend to be slightly runny but are an excellent rich colour, and if the paint seems too runny you can add a small quantity of gel medium (a thickener that appears cloudy when applied but dries clear). Interference colours, which show different hues when viewed from different angles, are also effective, especially when printed on dark materials, while iridescent tinting medium or pearlescent white can also provide a sheen to a print on a dark paper.

Making a Mono Print

You will need:
- A plastic sheet (polypropylene, a laminated sheet or even a piece of rigid plastic)
- A 2.5cm (1in) household paintbrush
- Several sheets of good-quality white cartridge paper – A4 (210 x 297mm/ 8¼ x 11¾in) or A3 (297 x 420mm/11¾ x 16½in)
- A good-quality acrylic colour
- Tools to draw into the print surface, such as a shaper brush, grouting tool, wooden dowel or thick stiff bristle brush, or even a plastic strip made from the lid of a food container or packaging
- Print roller (brayer or other soft rubber roller), any width

Preparation:
Prepare the printing area by covering your work surface with newspaper and cut the paper ready for printing. Place an ample amount of newspaper beside the paper and put the plastic sheet ready to be coated with acrylic on top. Put on an apron to protect your clothes.

Printing:
- Put a small quantity of the acrylic onto the plastic sheet and spread it evenly across the surface, brushing it to the edge of the plastic sheet. It is important that the colour is equally distributed across the plastic sheet.
- Take one of the tools and draw firmly into the printing colour. Try spirals, wavy lines, straight lines, zigzags, fine lines, thick lines, writing – any pattern that you can draw quickly. Use the same pattern repeatedly. Speed is really important as the printing colour will be drying and it needs to be moist when applied. Make sure that the outer edges of the pattern do not end too abruptly, giving a hard edge to the print. Instead, try to let the pattern flow off the plastic sheet.
- Take a sheet of paper and place it on top of the acrylic colour. Gently stroke the back of the paper to transfer the print. Be sensitive to the thickness of the paper, the depth of printing colour and how heavily you are pressing down on the reverse of the paper.
- Check how well the colour has printed off by carefully lifting a corner of the paper to see. If it looks rather indistinct, replace and press again firmly and evenly to achieve a good contact.

Build up your design by repeating this process onto the same piece of paper, adding more colour and drawing patterns into the printing colour so that the design can relate and easily overlap. Repeat on further sheets of paper. With a little practice, the printing process will become easier and it will be possible to predict the effect that you want.

ROLLER PRINTING

Print rollers are a quick and spontaneous way of adding both colour and differing patterns and visual textures to paper (or fabric). A plain roller that is covered in liquid colour can be used to 'pick up' the pattern from a carved or etched surface, which is then transferred to the print paper by rolling. Or a roller can itself be permanently carved or etched with a pattern that is coated with colour and rolled onto the paper.

Using a roller requires a little practice. You sometimes need perseverance and an awareness of your own sensitivity to handling equipment. Although printing from a roller may look easy at first sight, it requires a bit of skill: knowing how much pressure to apply is key to obtaining a satisfactory print. Many people are totally unaware of how heavily they are pressing down and become disheartened when no pattern appears. A more controlled pressure – not too heavy – is required.

Left: Mono print plus further roller and 'found object' printing on paper.

Using a Roller to Transfer a Pattern

It is best to print standing up so that the weight from your body is transferred through your arm and hand to the roller. Be aware of how heavily you are leaning and therefore pressing on the roller.

- First, coat the roller evenly with printing colour. To do this it can be useful to have a plastic printing sheet as your colour reservoir – coat this sheet with an even layer of print colour and then coat the roller from it.
- Holding the pattern or textured surface firmly, gently take the roller across the texture, watching the roller as its surface becomes patterned. Check that the pattern has covered the full circumference of the roller.
- Make sure the paper that you are going to print on is absolutely flat and smooth (the same will apply with fabric).
- Slowly draw the roller towards you on the paper, watching the pattern transfer from the roller to paper. It is actually possible to pull the roller towards you or away from you – what is important is to do it gently and slowly, so that you can stop when you are happy with the pattern.

Above: Sketchbook work, printed from a string-covered roller, inked and with some additional drawn colour.

Right: Block printing using a kebab-stick block on paper, acrylic printed and then inked.

After each rotation of the roller there will be a reduced coating and therefore the print will become less distinct, so keep enough colour ready to reload your roller when necessary. If the roller has too thick a coating of print colour it will slip and give distorted patterning. Conversely if there is insufficient print colour the roller will not be able to make a complete print. If the roller fails to print a pattern or texture, do not be downhearted. You could allow it to dry and then print a contrasting pattern or colour on top, for an interesting result. This technique takes a little bit of practice, so do not be put off if you find it hard at first – you'll get there in the end if you persevere.

Consider the placing of the print on the paper – it does not have to print from top to bottom in a straight line. For instance, try printing diagonally or horizontally across the paper, or printing in a wavy line or in short sections. You can also mask the paper so that sections of the print are concealed. And you do not have to print in straight lines; the roller can do curves or be taken diagonally across the print surface. You can also make a short print, lifting the roller and starting the pattern again further down on the paper. Or you can print the roller texture with one colour, then repeat the pattern in a contrasting colour. And all these ideas will work just as well on fabric, with slightly different results.

Making Patterned Rollers

You can permanently pattern a roller by attaching string, Funky Foam and flexible textures directly to the rollers using double-sided sticky tape (for instance, carpet tape). You can use similar methods as for making a print block (described later in this chapter). Once the roller is patterned, coat it with white acrylic to preserve it, and do not soak or immerse it in water.

Alternatively, you can use sponge rollers that are already cut with simple patterns such as ripples, wavy lines or chevrons (or you could cut your own). Sponge rollers are more absorbent than the harder print rollers, and it is easy for the sponge to become saturated with printing colour. This makes them excellent for printing on larger sheets of paper, or large heavyweight fabrics. However, sponges often aerate the print colour, giving a light, bubbly texture that is attractive, but may not always be what you want. Also, take care not to let the roller become over-saturated with print colour, leading to uncontrollable areas of liquid transferring to the paper.

Left: Taking a print off the roller from a block design.

BLOCK PRINTING

Block printing is a technique which uses a print surface that has been created with raised areas and voided negative areas. It is one of the oldest forms of printing; traditionally, very complex print blocks were carved in wood, with a different block for each colour. The printing was a long and laborious process requiring careful registration and a skilled, experienced printer to match the pattern and repeat. However, there are many ways in which you can create simple but effective blocks and use them to produce imaginative designs. Each block can be a separate stepping stone in the development of more intricate patterns, or can become the pivotal key to a series of designs, ideas and themes, in styles ranging from precise and intricate to accidental and organic.

Below: Print blocks made from foamcore board and pre-cut Foamtastic shapes.

Creating Simple Blocks

Before you can start printing with this technique you need to make some blocks. Making simple print blocks with foamcore board, double-sided tape and Funky Foam can be great fun. By just taking very simple shapes, hundreds of different patterns can be created and there is a mass of designs and colourways.

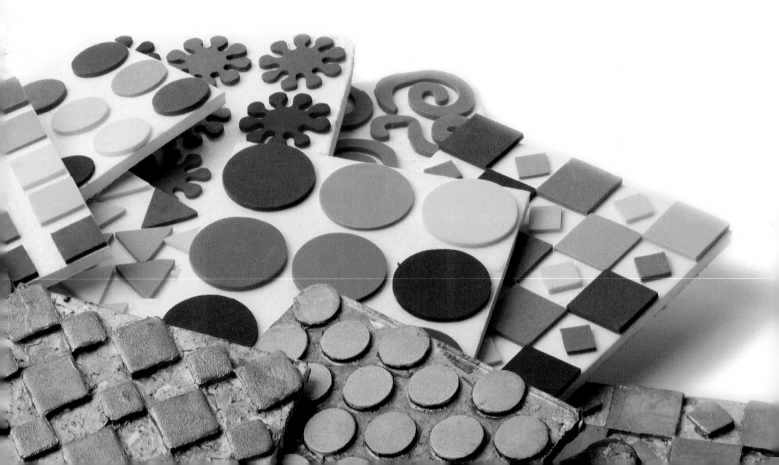

PRINT BLOCK MATERIALS

Print Block or Stamp	Advantages/Disadvantages
Lino – thin rigid surface, can be cut to almost any size required.	Drawn design can have a wide variety of detail and line quality. Can be hard to cut – before cutting warm slightly to soften, and use lino-cutting tools. Can crack and is brittle.
Speedy Cut – 5mm (¼in) thick, pink, flexible and can be cut to any size. Quite heavy.	Drawn design can have a wide variety of detail and line quality. Cut with lino-cutting tools. Flexible, possible to print small areas. Becomes slightly sticky after repeated use of different media. Surface will wear after repeated scrubbing and cleaning.
Safe-T-Cut – 10mm (½in) thick, semi-flexible, heavy.	Drawn design, can be cut with lino tools. Surface slightly rigid, can crack. Gives a stout, firm block.
PZ Kut – a bright orange, slightly plastic surface suitable for fine-line cut designs.	Thin, flexible block, very strong and suitable for intricate designs. Hard-wearing and fairly easy to clean, although surface will stain.
Foamcore board/Kappa board with double-sided tape and various raised additions.	A very cheap and immediate printing surface. Use double-sided tape to adhere 3D shapes for pattern. Easy to make, fun and very individual. Only wipe clean; board will bow when immersed in water. Wipe with baby wipes.
String blocks and foamcore board.	Excellent method of creating linear design. Important to use a stout, firm string and double-sided tape and prepare the surface well.
Heat and Press – a block that will impress when heated, forming a raised or highly textured surface.	Good for quick unusual textures and patterns rather than individual drawn designs.
Press Print – dense, fine polystyrene sheet.	Simple and smooth surface for drawn design using a sharp tool. Gives delicate prints but is quite vulnerable. Useful when developing ideas, especially on paper. Cheap.
Miracle Sponge – a thin sheet that expands in water to twice the depth and width.	Easy to cut, especially for slightly intricate designs. Good for printing, although can be messy. Remains enlarged once exposed to liquid.

Making a Block from Foamcore Board

You can make a simple block from very stout cardboard or even better a piece of foamcore board (Kappa board). This is a 5mm (¼in) thick sandwich of card and polystyrene. It is easy to cut, is lightweight and is often used by model makers and architects. Cut a design from Funky Foam or Foamtastic and attach it to form the print pattern (see below for method).

Foamtastic is available in many pre-cut simple geometric shapes such as squares, circles and triangles, as well as simple letters, flowers, hearts and other motifs. You can arrange these shapes and re-cut them to give an even greater range of patterns. It is also worth exploring the possibilities of simple squares, making grid patterns and using large and small squares in turn. You can vary the voided areas (those that will not pick up colour) by using the same sized squares but varying the spacing between them, by placing the squares in an even grid order or by offsetting them in a brickwork pattern.

Construction:

- Using foamcore board (Kappa board), cut a square or rectangle about 10 x 12.5cm (4 x 5in).
- Cover one surface with double-sided sticky tape or carpet tape.
- Using scissors or a craft knife, cut a simple pattern using Funky Foam or Foamtastic. Carefully place the pieces of the design onto the double-sided sticky tape and press down with the print roller.
- Lightly coat the block with white acrylic to seal exposed areas of sticky tape. Allow to dry before use.
- After use, wipe the block clean with baby wipes or a damp cloth rather than washing it. Immersing in water will cause the foamcore board to bow and any adhered items to dislodge.

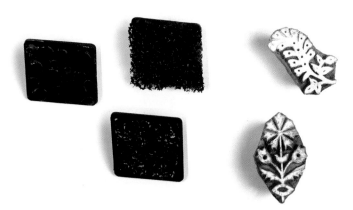

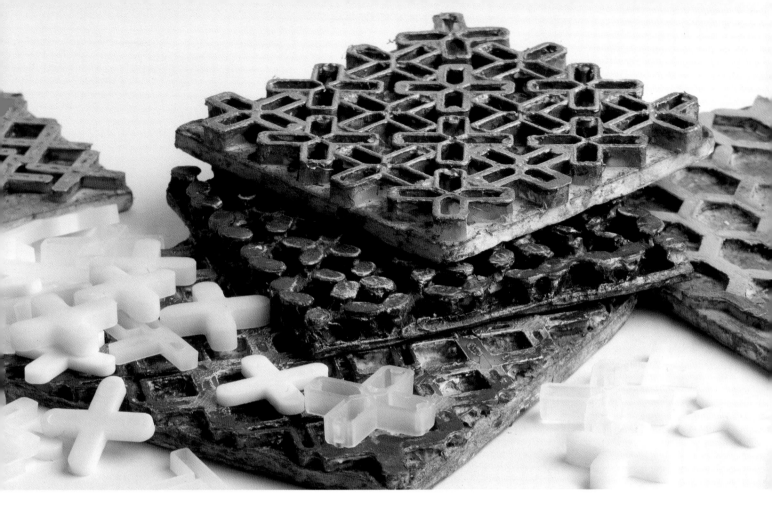

Making Blocks from Found Objects and Junk

Above: Blocks made from tile spacers.

Left: Print surfaces. From top: Heat and Press, PZ Kut, Miracle Sponge, Embossing sheet, Speedy Cut, lino.

Far left: Pre-cut Indian wooden blocks and mass-produced plastic printing stamps.

You can make an interesting print block from everyday objects that are intended for other purposes but have shapes and textures that will work well for printing. Spend time searching for interesting objects that will give a raised patterned surface. Garden centres and DIY (home improvement) shops can be a marvellous source for different items. Collect tile spacers, available in X, Y and T shapes as well as thin, thick and chunky textures. Plastic green garden ties with little arrowheads make good linear patterns, as do kebab sticks or wooden skewers.

Construction:

- Cut a square or rectangle of foamcore board, about 10cm x 12.5cm (4 x 5in), a shape that is easily held in your hand.
- Cover one surface with double-sided sticky tape or carpet tape, but do not peel the protective paper from the upper surface yet.
- Select suitable items, making sure that they are the same depth so that you will have an even print surface.
- Remove the protective paper from the double-sided tape and arrange the found objects (tile spacers, garden ties etc.) onto the sticky surface.
- Using a print roller, press the top surface hard to ensure that the items are firmly attached to the sticky tape.
- Before printing, lightly coat the print surface and exposed tape with white acrylic, allowing it to dry naturally. The white acrylic will help to seal the sticky surface and give a bit of grip when printing.
- Always wipe blocks clean with baby wipes or a damp cloth rather than immersing them in water.

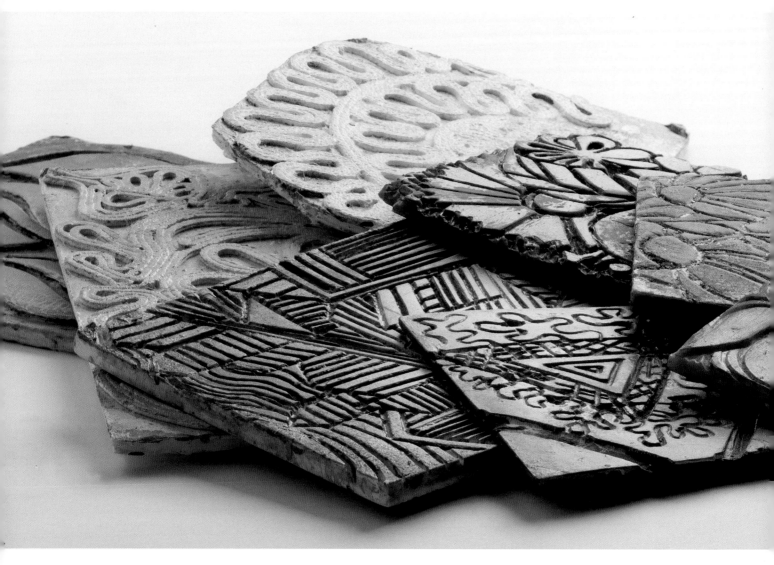

String Blocks

A print-block surface covered with a string design provides a very effective texture. A medium-weight 'butcher's string' is a good choice, since it will not flatten when under pressure from the print roller.

Construction:
- As before, cut a rectangle or square from foamcore board (Kappa Board).
- Cover one surface with double-sided sticky tape or carpet tape.
- Begin to lay the string in a linear pattern, if possible getting it to go up and down in a single continuous line, allowing it to twist against itself. Using the string double will give a strong design (see the examples above). Do not let the string cross over itself because this will create an uneven surface.
- Once the design is complete, use a print roller to apply white acrylic paint. Allow the string to absorb the acrylic, taking care not to soak it because this will make it fall away from the sticky tape. Use a roller to permanently press it into the double-sided sticky tape. When the string is well adhered allow the block to dry without wiping. It will then be ready for printing with other acrylic or fabric-printing colours.

Above: Print blocks made from foamcore board and Funky Foam and string, lino, Speedy Cut, Safe-T-Cut and PZ Kut.

Cut Print Blocks

Print blocks can be cut from a number of different materials such as lino, Speedy Cut, Safe-T-Cut and PZ Kut, as listed in the equipment section.

When designing a print block it is important to consider which areas are going to print, and to plan the positive and negative areas accordingly. Effective patterns have strong lines and clearly defined shapes, and you should consider the direction of lines within the main design. Once a print block is cut, the design can be used repeatedly in many different ways, such as formal, symmetrical arrangements, random positioning, half dropped, bricked, turned and repeated.

Cutting a design is irreversible, so try developing drawn ideas in a design book before you start to cut your design. Play around with different arrangements and patterns before finally selecting your design. See *A Floral Collection* (chapter 4) for another example of developing designs using cut blocks. Consider the spacing between the drawn shapes and therefore the negative space, which will be very important when roller printing. Ensure that there is visual movement across the block, whether it be from top left to bottom right (or vice versa as the block will print in the reverse) or in the centre of the block. Try and make sure the eye is led through the pattern and can move on to the next area of printing rather than creating a design that is complete in itself.

Finally, think carefully about how large you want the elements of your design to be. This can vary depending on what you wish to print and will be important when it comes to printing repeated blocks on large areas of fabric. For example, if the design is to be used on small, delicate fabrics then an intricate fine pattern may be suitable whereas a large bold pattern might be necessary on a large, substantial fabric.

Cutting the block:
- IMPORTANT: Always hold the edge of the block nearest to you and cut away from you. The lino tool is very sharp and it is very easy to sustain deep and painful cuts by cutting towards yourself.
- Select a design and mark the areas that are to be cut out using a fine line or ballpoint pen. You can trace a ready-drawn design onto the block surface using a very sharp pencil or a stiletto.
- If using lino, warm it for a few minutes on a radiator to soften it, making it easier to carve.
- Choose the finest lino cutting tool you have and outline the main shapes of the design, taking care to cut outside the line, so as not to reduce the print area. Do not cut too deep at this stage and try to make sure that the cut is even and smooth.
- Once the design is outlined, select a wider lino blade and cut away deeper areas and carefully define the drawn shapes. Do not dig too deep because this will cause the block to crumble or split.
- Be prepared to adjust your design once you start to make it into a block. This is especially important when you are cutting with lino cutters as it is not always possible to cut very fine lines.

- Take care to cut slowly and carefully – more can be cut away later, but it is impossible to stick it back on!
- Check the block is sufficiently cut by taking a simple rubbing using a soft pencil and some tracing paper. This will show if more areas need to be cut or refinement is required.

Press Print

This is a smooth polystyrene tile that will create fine lightweight temporary print blocks. The surface is easily indented using a sharp object such as a ballpoint pen or a tapestry needle. Drawing into the surface of the tile gives simple bold linear patterns. The Press Print surface is delicate and is well suited to paper printing, and also for printing on fine fabrics such as chiffons, organdie and voiles.

Heat and Press

This specialist material provides a quick way to make a print block. Gently heat the block until it is warm. Immediately press any three-dimensional pattern into the surface and hold it in place for about a minute until the impression has indented the surface. The block can be used immediately.

Basic Block Printing Using Simple Blocks

Now that you can make a range of blocks, it is time to start using them to print. The example below provides an introduction to block printing using the blocks you have made.

You will need:
- A printing plate or sheet
- A rubber print roller
- Acrylic paint in two or three colours of your choice
- Paper – good-quality smooth cartridge paper
- A selection of print blocks made from foamcore board and found objects, as described in the previous section

Block printing technique:
- Squeeze a small quantity of acrylic colour onto the printing plate.
- Carefully roll the print roller in the acrylic colour until it is evenly coated.
- Apply the acrylic colour to the print block by rolling the print roller across its textured surface, making sure that it is evenly coated.
- Print the texture onto the paper, repeat colour application to the block and then use it to print again.
- Build up the print, trying different arrangements of the pattern, altering the colour and then allow it to dry.

Developing Designs through Block Printing

There are many ways that you can experiment with block printing to build up designs. It is worth making a reference file of ideas using each block, exploring the various possibilities of every block, either alone or in combination with others. Here are a few design ideas that combine block and roller printing; others can be found later on in this book in the section on fabric printing.

- Take a block and use it to print in a series of different colours. Start with yellow and make a print then, without cleaning the block, add a little red and print again. Then add magenta and print again. Finally, add white and print again.
- Take the same block, print with the same colours as above, but this time use the print off the roller. (That is, use the roller printing technique to transfer the print block pattern to the roller, then apply the roller to the paper.) See how the pattern alters from just block printing, and observe the effect of adding the different colours to the block at each stage.
- Try block and roller printing together, place roller printing on top of block printing and vice versa.

There are many other ways that you can vary the printing by your use of colours and print media. For instance, you can use a darker paper, and add either white or iridescent tinting medium to the acrylic colour so that the print is visible. Or you can use light acrylic colours on a light-coloured or white paper and print a number of pattern ideas; once the prints are dry paint them with either transparent ink or diluted Procion MX dye colour to alter the original background colour – watch the printed pattern miraculously 'emerge' through the ink colour.

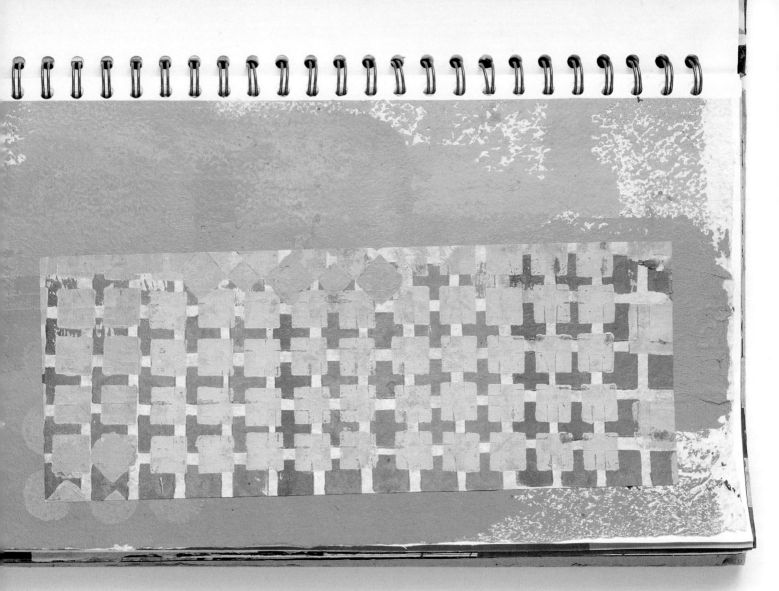

TAKING PRINTED PAPER DESIGN FURTHER

Printing on paper offers a wealth of possibilities. You can try printing on different types of paper, including tracing, greaseproof or tissue paper. You could also use old pieces of paper that have had oil pastel or Markal (Shiva) Paintstiks applied (see chapter 6 for more information on Markal Paintstiks). Once the oil pastel is fully absorbed, try printing with acrylic on top. In addition to Markal colours the two blending sticks also available, iridescent and professional, are excellent on paper, especially when combining colours and as a resist with an ink.

The kind of paper you use will affect the way colours and inks combine. An effective technique is to print strong acrylic colours such as golden yellow, orange, turquoise and green on a strong cotton rag paper. When dry, paint the paper with a contrasting ink or Procion MX dye, such as a purple. Allow the ink to soak into the background paper, and if necessary wipe it away from the surface of the acrylic print.

Over and above your paper choice, the way in which you choose and use colours together will dictate the look of your finished design – from vibrant, eye-popping combinations to subtle, atmospheric shades.

Above: The possibilities of geometric patterns – exploring simple square arrangements.

Colour Combinations

Try layering colours: for example, printing reds and oranges first and then, when dry, printing a contrasting colour such as a light turquoise on top. Similarly you can print pure colour, without any pattern, from the print roller. When this is dry, add a printed pattern. Explore unusual or adventurous colour combinations, such as trying red onto pale yellow, then add turquoise and finally green. Once you have created a range of different samples, cut them into pieces and rearrange them together, so that you can get an idea of different colour groupings. Don't forget that these ideas can help you to consider designs for printing on fabric as well.

Geometric Patterns

Designs built up from repeated printings of simple geometric shapes – squares, spots, circles and dots, for instance – can be quite eye-catching and capable of great variation.

For example, squares can be set in a grid pattern, with equal spacing between them, but then the same pattern can be repeated with the squares further apart, or nearer together. Simply turning the square by 90 degrees provides a diamond shape.

Varying the size of the squares used provides a different sense of the negative space around the printed square. Alternatively, a block that is cut out as a reverse pattern (printing the negative space rather than the square shape itself) is also effective. Stacking squares of three different sizes in a pyramid shape results in a stepped ziggurat shape. For more inspiration, have a look at tiled floors – particularly those in Victorian and Edwardian buildings – and see how squares are arranged there.

Circles, spots and dots are also effective for design-building. All circular shapes are difficult to draw and cut accurately, but have a look around and you will find there are numerous circular items available, such as washers, bottle tops or corn plasters as well as pre-cut children's shapes in Funky Foam.

Build designs by spacing the dots regularly, even measuring so that different blocks can be printed together, either by spacing the print in the gaps or by overprinting. Scatter different-sized dots across the block to give a random effect, or even make two or three blocks in this manner using different-sized spots. Repeatedly printed, these will create a pointillist effect that can be especially attractive if you use different shades or tints of one colour.

Triangle shapes can be formally arranged in tiers, using equilateral triangles with the largest placed at the bottom. Position the base of each triangle symmetrically on the point of the one below, thus building a tower.

You can build lines, waves or curves made up of triangles, aligning them carefully so that the points of the triangles form the trajectory that the eye follows. Alternatively, random arrangements of triangles printed repeatedly can give subtle textured patterns, and triangles and squares mix well in formal geometric patterns.

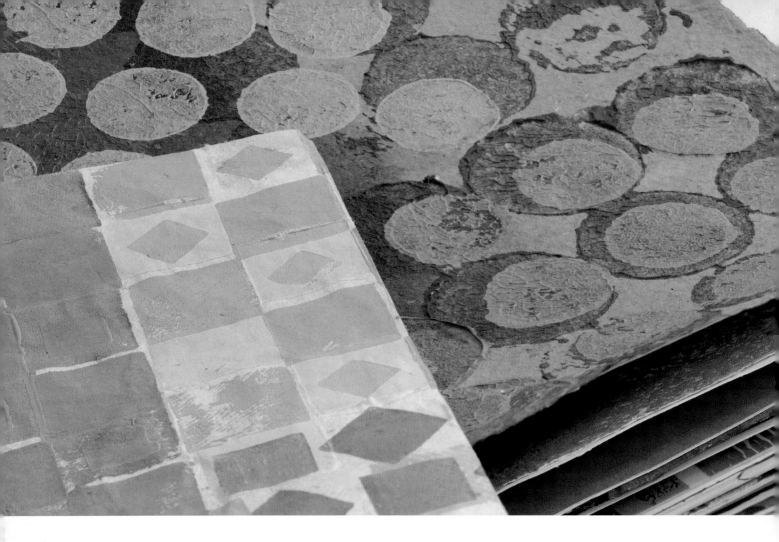

OTHER TECHNIQUES FOR BUILDING PRINTS

Complex and technical print processes require complicated recipes, space and a degree of
time and expertise. But it is certainly not always necessary to have expensive equipment or
masses of space to achieve beautiful, dynamic and spontaneous prints. Here are a few ideas
that show just how effective the simple techniques covered so far can be, especially when
used with a sensitive approach to the surfaces and the colour mediums available.

Print-Roller Patterns

Squeeze a small quantity of acrylic colour onto the plastic sheet (your print plate) and
spread it with the print roller until the sheet is evenly coated. Depending on the thickness
of the acrylic colour, the roller may create little rippled lines in the paint on the plastic,
which will be retained when printing, provided the paper is pressed down lightly. (If
pressed too firmly the print will tend give a flat, less textural effect.) You could also draw
into the colour on the print plate before printing from it.

Above: Experimental
pieces using geometric
patterns, spots and
squares.

Right: Roller-printed
ripples in orange acrylic.

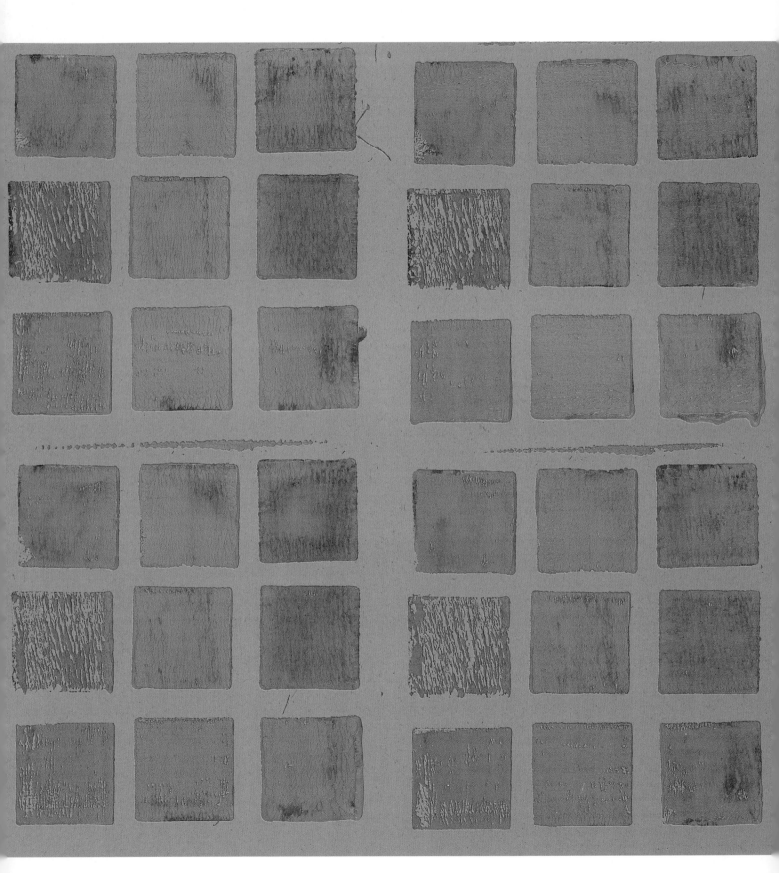

Using Two Plastic Sheets

Left: Block printing in orange on teal-coloured paper.

Above: Print taken from block impression on plastic print sheet.

You can use two plastic sheets together to create unique patterns that, to my mind, are always especially individual and 'organic'. The kind of prints will be governed by a number of factors, including the amount of print medium on the plastic sheet, the medium's viscosity and how evenly the colour is dispersed.

Apply a generous coating of acrylic colour to a plastic sheet and try to spread it evenly. Then press a second clean plastic sheet down on top of the paint, in a sandwich. Peel the two sheets apart carefully and you will be left with two sheets coated with colour, one the mirror image of the other. You can then apply paper to both, individually, to obtain prints.

This technique can be varied to give different effects. For example, apply the printing colour plus a little white in the centre of the first plastic sheet before placing a second sheet on top. Lightly press together and then, holding the two sheets in your hands, twist them in different directions (without letting them part) in order to spread the print colour. When you pull them apart you will find a circular, shaded pattern.

Another trick is to place three areas of printing colour such as yellow, turquoise and magenta on the first plastic sheet before placing the second sheet on top and twisting it through 360 degrees. Peel apart to reveal gently mixed colours ranging from yellows, through greens to blues, violets, magenta and orange.

Wonderful fern-like patterns can be obtained by applying vertical lines of printing colour on the first plastic sheet before pressing down the second sheet (without turning it). And, finally, try drawing into the print colour before making prints. Once you have peeled apart the plastic sheets you can take a shaper brush, fine bristle brush, grouting tool or wooden dowel and carefully draw into the patterned surface. Shapes such as leaves, circles or squares can be used to contain the more organic patterns created by the paint, thus emphasizing the unique nature of this kind of patterning.

The above techniques are all examples of mono printing, in that they cannot be used to make duplicate prints. There are several other ways that you can vary your mono prints. For instance, try printing onto a coloured paper using acrylic colour with a little white added. This can generate a very lively colour combination, often making the print colour reverberate against the background.

Creating Textures

Interesting textures can be obtained by using everyday objects. The list is endless, but includes materials such as bubble wrap or hot-tub cover fabric, pill packets, household plastic mats with perforated or punched surfaces, shoe soles, bicycle-tyre tread, plastic canvas and various garden meshes. Use your imagination, since many 'found objects' give wonderfully interesting patterns and textures to printed surfaces.

All the techniques below can be used effectively on either paper or fabric, although materials especially suitable for fabric will be discussed later on. For the moment explore some ideas on paper and see the huge variety of patterns that can be created from simple beginnings.

As an example, apply an even coat of acrylic colour onto the plastic sheet and impress bubble wrap into the surface of the plastic sheet repeatedly. Take a print from the plastic sheet, and you can also take one from the bubble wrap itself. Change the colour on the plastic sheet, cleaning first with a baby wipe, and repeat the printing process by slightly offsetting the pattern. Try to use the same pattern repeatedly to start with, in order to build up the pattern and give the design continuity. This same process can be used with all kinds of materials.

Finally, if you find that a print is too thick and wet, take a contact print from the wet print, using a lighter weight paper. To do this, carefully lay a flat clean paper sheet over the wet print, gently press and remove immediately to take away the excess colour.

Right: Hot-tub print on paper that has previously had Markal (Shiva) applied to it.

Below: Textures for printing from everyday materials – bubble wrap, hot-tub cover, pill packets, plastic canvas and carved rolling pins.

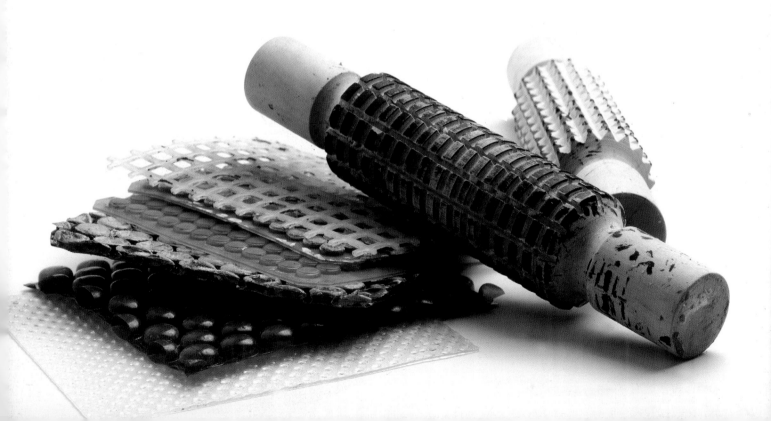

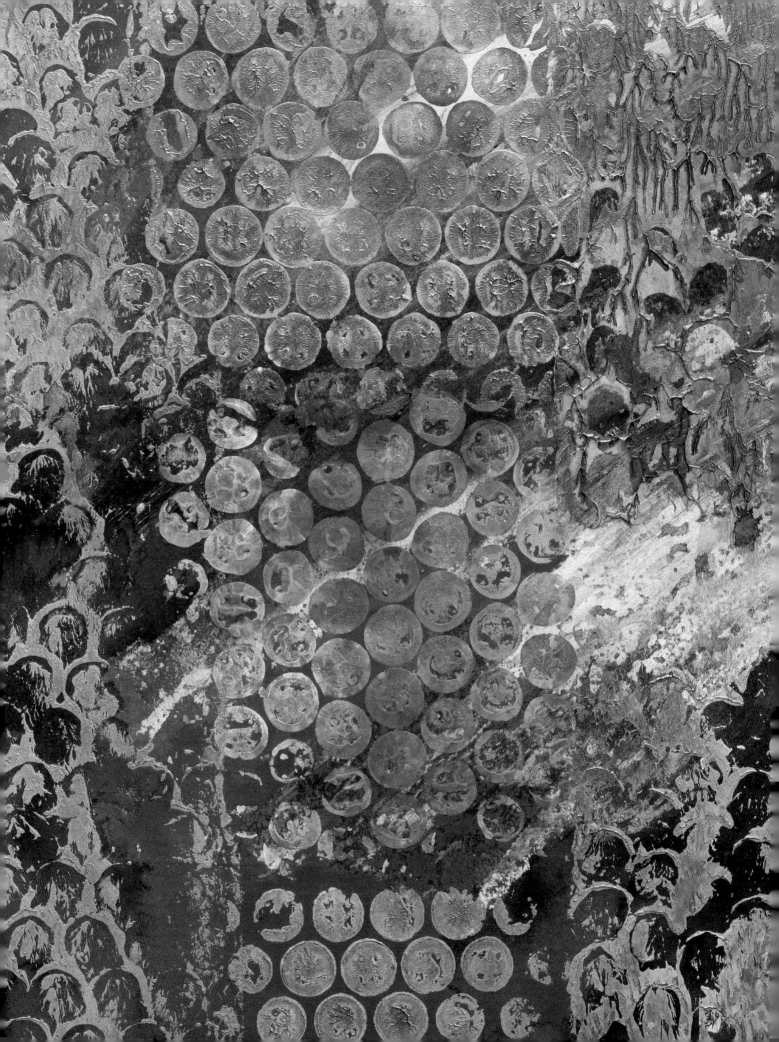

Top right: Printing using plastic canvas directly off the roller, in yellow and violet acrylic colour.

Bottom right: Plastic canvas printed and roller-printed and then overinked.

Above: Roller print using plastic canvas and pill packets.

Left: Print using plastic canvas.

Chapter 3
Printing on Fabric

As soon as you start printing fabrics, endless possibilities come to mind. The techniques covered in Chapter 2 are just as effective on fabric, and can be used in different ways – now with even greater exploration of colour and texture.

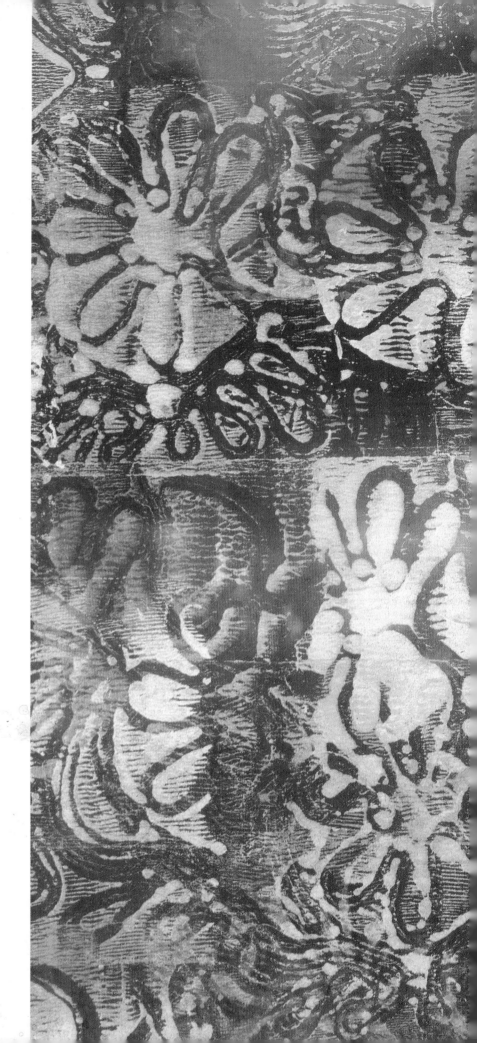

Right: Roller print from floral string block using textile colour and then overdyed.

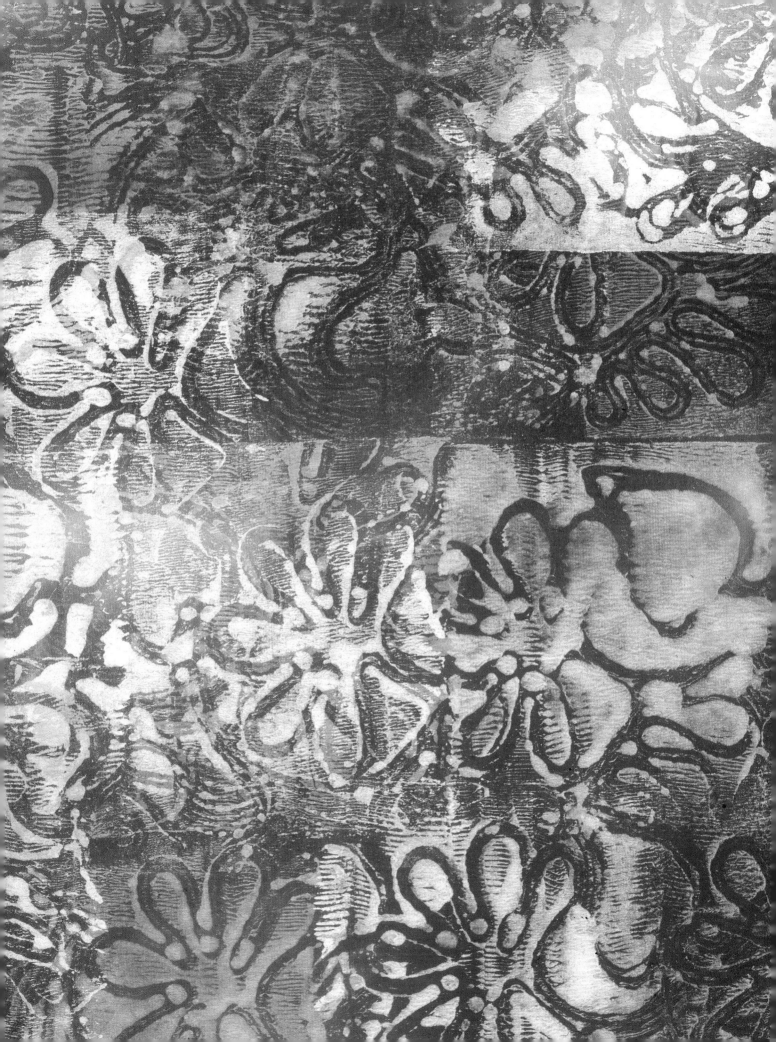

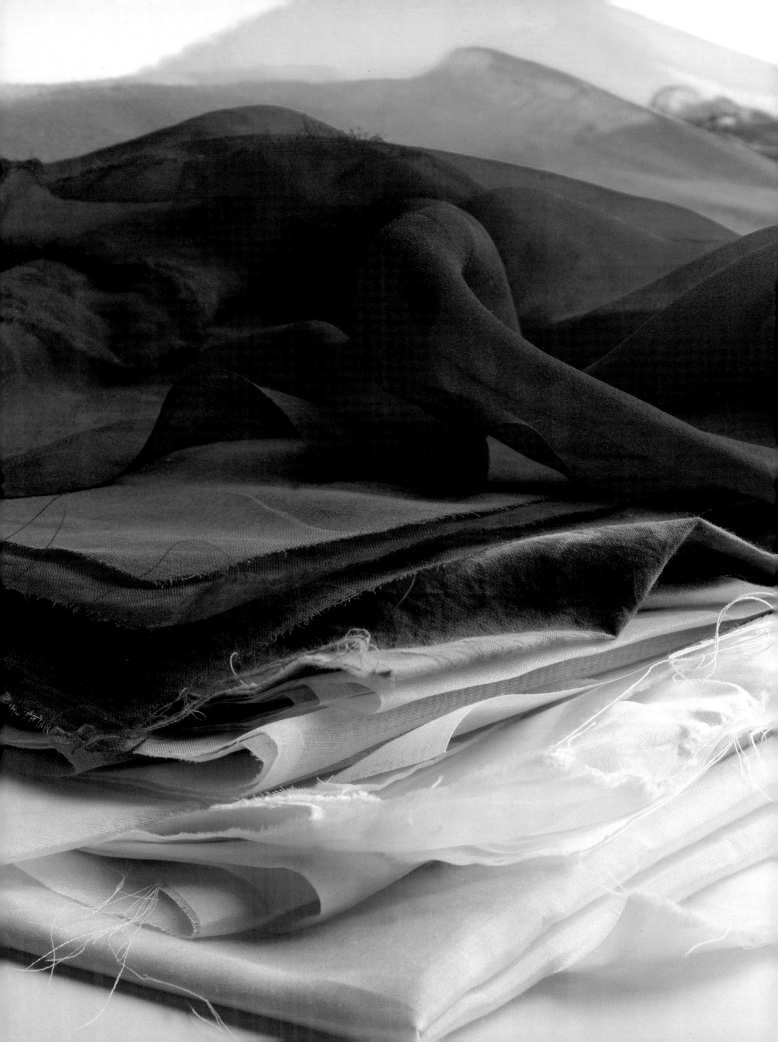

CHOOSING FABRICS

First of all, you need to consider your fabric and the print medium you will use. Think of printing on fabric as like making a sandwich – with the fabric on one side, the print block on the other, and the print colour providing the filling. It is important that the print colour 'filling' penetrates the surface of the cloth well, and will be absorbed sufficiently without spreading. When starting out with printing on fabric it is best to make things as easy as possible by choosing both fabrics and print colours that work well for the purpose.

When selecting fabrics, first consider the nature of the fabric's surface and look at its fibre content. The fabric must be able to accept the print colour when it is applied, so it needs to be absorbent and smooth, but not too shiny. Imagine viewing the fabric through a magnifying glass; this can help you to understand physical problems that can occur when printing. For example, imagine a piece of close-woven cotton such as a crisp cotton poplin, percale or cotton sateen. The threads are fine, the weave is tightly packed and there may be up to 200 threads per inch. Being cotton, the fabric is slightly hairy – but that helps it to absorb the moisture of the print. These kinds of fabrics will absorb layers of printed colour well and, due to the closeness of the weave, give crisp images.

Now imagine a piece of silk viscose velvet or cotton velvet. These fabrics are beautiful when dyed because of their deep-piled surface, and will retain colours well. However, printing on them is like working on a piled carpet – the fibres easily clump together when the textile print colour is applied. But if you select an alternative print medium, such as thickened dye, this kind of fabric returns to its thick and luscious soft surface after washing.

Many fabric-printing colours are designed to be used on all fabric types and are usually heat-fixed for permanency. Even so, fabrics and fibres do vary in their absorbency: a synthetic fabric such as acetate often has limited absorbency, whereas a cotton or linen can be very absorbent. This will affect how the colour looks on the fabric.

Both the weight of the fabric and the nature of its surface will also affect the print quality. Silk, for instance, is available in featherweight chiffon and organza, which are virtually transparent. Habotai, on the other hand, comes in a variety of weights but is always smooth. Silk dupion is a fine but uneven shiny slub silk, whereas silk noil is a rough, matt fabric that has virtually no sheen. When handling sheer fabrics the amount of print colour has to be limited, while the more absorbent fabrics require proportionally greater quantities.

The ground colour of the fabric will affect the appearance of the colours in the finished print. For example, on a light or white fabric all printed colours will be visible, so yellows, blues and reds can be printed and overprinted to create multicoloured fabrics that still retain the neutral base colour. Selecting a fabric with a non-neutral colour can be useful, since all colours applied will be affected by the nature of the base colour. For instance, unusual colour combinations such as reds, oranges and russets can be obtained using a fabric with a yellow background. For darker materials, however, various strategies are needed to make the applied colours visible: an opaque, pearlescent, iridescent or metallic colour might need to be used.

Left (from bottom to top): Fabrics good for printing: silk organza, cotton organdie, silk habotai, viscose satin, silk viscose satin, fine cotton calico, heavy silk organza, close woven silk rib, cotton/silk mixture, cotton poplin, dye-painted cotton poplin, low-immersion dyed spun rayon, dye-painted calico, dyed silk chiffon.

Remember that each layer of colour should be able to 'key' into the cloth surface. Building one printed colour on top of another may eventually create a barrier between the print medium and the actual fabric. This could ultimately prevent the later layers of print colour from attaching or penetrating the cloth. This can easily happen when using opaque printing colour or printing onto a very shiny fabric.

The following fabrics and fibres will give a good printing surface:

Cotton
- sateen
- percale
- furnishing satin
- poplin
- voile
- calico – lightweight
- organdie
- velvet

Silk
- satin
- medium-weight habotai
- silk noil slub
- organza
- dupion
- silk mixtures, such as silk and cotton or silk and viscose satin

Viscose and rayon
- spun rayon
- viscose satin
- cotton-backed viscose satin

Right: Markal (Shiva) brushed off masking tape and rubbed over plastic canvas on vibrant dye-painted cotton.

There are many other mixed fibres you can use, such as polyester cotton or hemp and linen, as well as specific weaves. It is worth using a reputable supplier where there is continuity of stock and the fabric weaves and fibre content are both clearly identified. Most of the fabrics suggested tend to be either cellulose-based or silk. This enables you to dye the fabric before or after printing, which provides even more flexibility.

Preparing and Fixing Fabrics

Some fabrics are sold prepared for printing and dyeing, but others need to be prepared. To do this, first wash, dry and iron your fabric. Use specialist fabric-preparation products such as Synthropol or Metapex to scour the fabric – mix a very small quantity in very hot water, soak for 20 minutes, then rinse and dry. This will ensure that all dressing has been removed, allowing for greater absorption. If possible, pin or stretch the fabric taut on the printing area before printing since this will help the smooth running of the printing process.

Most fabric mediums need to be heat-fixed after application (usually by ironing at a high heat for several minutes) for permanency. Instructions are given on the container or by the manufacturer. Remember that once a fabric medium is fixed and washed the fabric goes back to its natural state, so further processes can then be added and these in turn can be fixed. However, take care not to apply too many layers of printing, as this can prevent later layers of print fully absorbing into the fabric. Be particularly aware of this on shiny or rough fabrics.

Never be afraid of fixing and then laundering the fabrics, allowing them to return to their true nature and lustre. Problems that occur can usually be analysed and causes found, and then you can try again. Alternatively, those 'mistakes' can turn out to be a chance to develop some creative thinking and produce imaginative solutions.

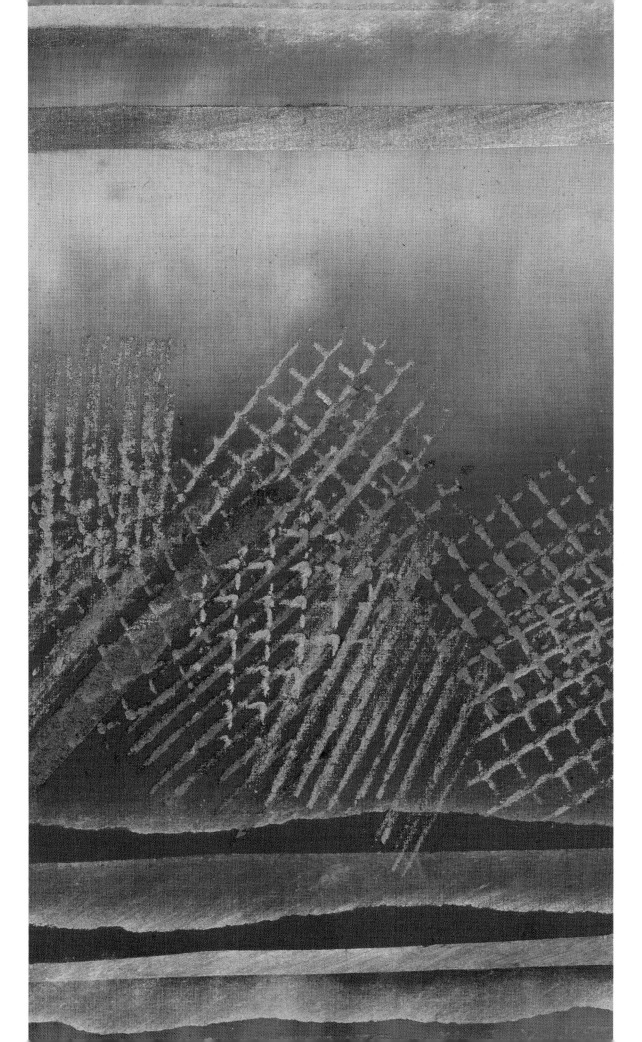

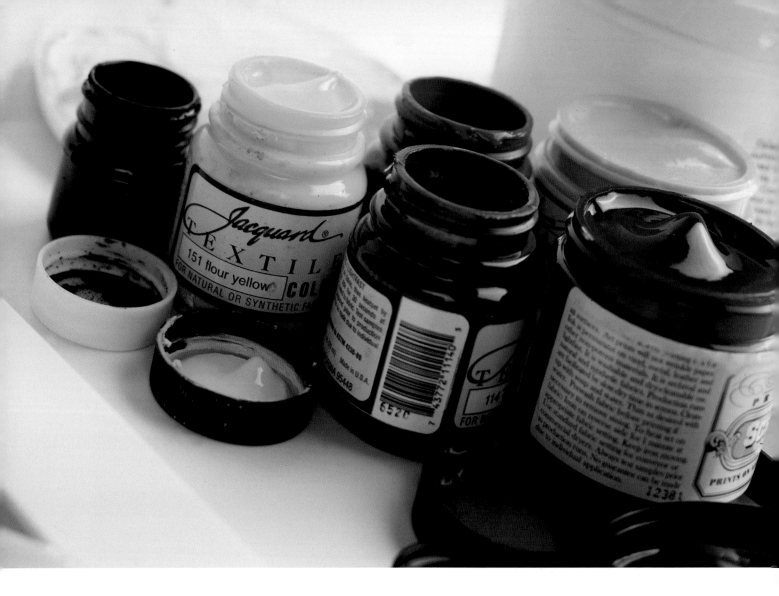

PRINT MEDIUMS FOR FABRIC PRINTING

Before choosing a fabric-printing colour it is important to be aware of the choices available to you. Bear in mind the amount of printing you wish to do, and whether you intend to make up your own colours, since storage space is an additional consideration – as is expense.

Above: Selection of fabric-printing colours plus print pigment and binder.

When starting out you may be content with a small selection of ready-prepared print colours. Later you may decide to invest in a wider range of print media that will give you more flexibility and range as your printing develops. On the other hand, you may decide from the start that you want to specialize in using print or patterning techniques in a very specific way, using metallic paints for instance – in this case you only need to select a narrow range of print mediums. Some of the more commonly used print mediums, and their properties, are listed below.

Acrylic colour can be used to print onto all types of fabric, either used straight from a bottle or tube or thinned with a fabric medium to make it more fluid. This kind of paint is good for quick projects, and for small areas of print and pattern because it is permanent without heat fixing and dries quickly. However, it will always impart some stiffness to the printed fabric.

Fabric paints or **textile colour** come as pots or jars of ready-coloured textile paint, available in numerous varieties and brands (and varying accordingly in price and quality).

Look for manufacturers who offer a good colour range, especially in 'essential' colours such as turquoise, ultramarine, lemon, golden yellow, scarlet and magenta.

The ready-mixed colours are usually of similar intensity, although some manufacturers also supply a colourless extender. This is a binder that can be used to dilute the pigmented colour, making it less intense and saturated, without changing the paint's consistency. Colours can also be lightened by the addition of white but this can give a chalky quality, as well as an opacity that may not always be desired.

All fabric paints that are heat fixed can be applied to all fibre types. There are numerous fabric paints available and a quick search on the internet will give endless manufacturers and information. Be careful, because there are other textile paints – often termed 'silk paints' – that are more fluid and not suitable for printing.

Iridescent or **pearlescent fabric paints** have an added sheen that makes them luscious in appearance and excellent for printing onto dark fabrics. They often come in a small bottle that makes them handy for a quick print on a small scrap of fabric. In addition to single colours they are sold in special dual combinations – for instance pink-gold and blue-green – that can be used to give the print an exotic effect.

Screen colour is a combined system of liquid pigment colour and binders, designed for use in screen printing. However, this can be used for all types of fabric printing. Since it involves a little more preparation, and more initial investment, it is most suitable if you are printing a quantity of fabric. Available in a limited range of colours such as lemon, golden, scarlet, magenta, turquoise, ultramarine, black and white, the pigments are very intense and only a small amount is necessary to colour the binder. Usually 1 part pigment to 20 parts binder is sufficient.

The type of binder used will influence how the colour will be affected by the fabric's colour. **Standard print binder** gives a pure translucent colour that, being translucent, is affected by the colour of the fabric. On a white fabric the colour will appear translucent but, for example, yellow printed on a blue fabric will appear green, and on a dark blue fabric will be virtually invisible. **Opaque binder** is a matt print binder that remains constant on a coloured fabric. So opaque yellow will be visible on a dark blue fabric although it will have a slightly chalky quality and the colour will change slightly. **Pearl** or **iridescent print binder** is opaque, visible on a dark fabric and has a pearly sheen. Add pure colour to a pearlescent binder to achieve both delicate and rich colours; for example, adding yellow ochre to a pearl binder results in a light gold, while a scarlet pigment creates delicate pale shell colours or rich coppery reds. Pearl binders also tend to give a softer handling surface to the finished fabric than an opaque binder. There are additional binders available such as a gloss, thermal and a three-dimensional puff paint.

Lustre and **bronze powders** provide great flexibility and choice, but do involve a bit of preparation and some initial expense. Please note that it is essential to wear a dust mask when measuring and mixing these powders.

Bronze powders, such as the metal powders from Robersons, are superfine quality and must be mixed with a binder, Ormoline, before application (1 teaspoon of bronze powder to approximately 1 tablespoon of binder). Once applied to fabric and dried they give a clear metallic sheen and leave the fabric soft to handle, and they are particularly recommended for natural fibres. Heat fixation is necessary for permanency (see manufacturer's instructions for method). Available in seven different golds, five different coppers, and bronze and silver, they must be used immediately once they have been mixed with the binder.

Lustre powders are readily available in pots and come in numerous different colours – from blue, greens and reds to coppers, bronze and golds, as well as dual colours – under the common brand names of Cornelissens, Pearl Ex and Brusho lustre powders. Made from mica flakes that are titanium coated to imitate different metallic and iridescent colours, the range of types is vast and very varied, and can give delicate sheer effects or a dominant sheen when printed. To give a good lustrous sheen, mix one teaspoon of lustre powder to one tablespoon of binder.

It may be necessary to undertake a little research to decide which binder is most suitable for your requirements, but the following give very satisfactory results:

Adva-Print clear binder is a milky, lightweight binder that dries clear, is suitable for all fibres and leaves fabrics with a good 'handle'. It appears cloudy when mixed before printing, but once absorbed into fabric becomes clear. For permanency, heat fixing is necessary.

Delta Textile Medium is a milky binder that dries clear. It has a good handle when washed and can be applied to all fabrics. Heat fix – see the chart on pages 54–55.

Ormoline Fabric Medium is a slightly latex binder that is a little heavier but works well on heavier natural fibres and is used mixed with metallic paints. Heat fix with an iron for four minutes to provide permanency.

Acrylic wax can also be used with lustre powders. It can be brushed onto fabrics but is rather too runny to be used as a printing medium.

All these binders can be mixed and stored for a limited period – a few days – in airtight tubs.

Thickened dye: Procion MX dye mixed with **Manutex (Sodium Alginate)** – is excellent for transparent colour that will fully impregnate the fabric, but is only suitable for natural fibres (cotton, linen, viscose, rayon or silk). The fabric is usually prepared by pre-soaking it in a solution of soda ash (or washing soda). Manutex has to be prepared in advance, so a certain amount of planning is required.

With thickened dye it is possible to create intensely complex prints without altering the handle and quality of the fabric, since although the fabric becomes stiff when printing, it regains its handle and lustre once fixed, washed and dried. The dye itself appears dark until

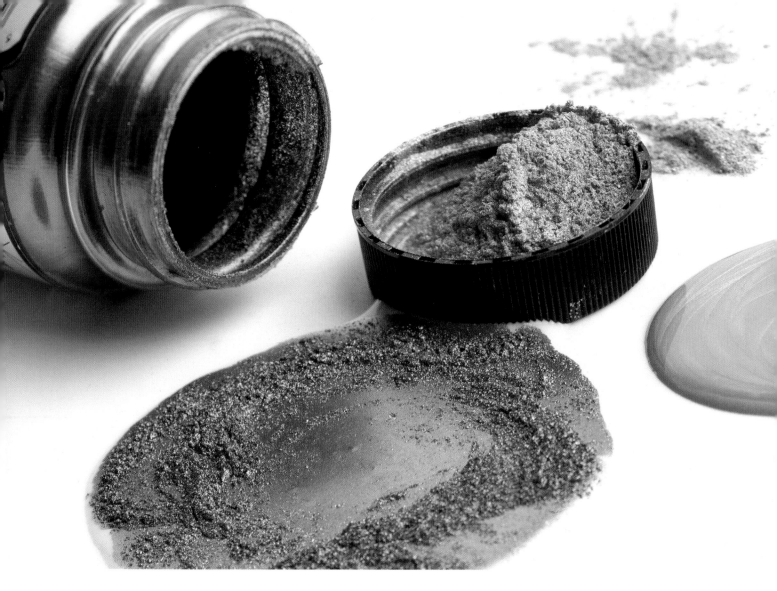

Above: Pearl Ex powder,
bronze powder mixed with
Ormoline, and ready-
mixed Lumiere.

fixed and washed, when it returns to vibrant pure colours. However, using thickened dye successfully requires an understanding of the use of layers of transparent colour, and how each layer will affect previously printed colours. One advantage of thickened dye is that it is very economical: large quantities of thickened dye can be made up and stored for a limited period, usually weeks, in a cool environment. But it is a dye, so care must be taken to wear gloves and protective clothing. Since it is very fluid and will absorb quickly through the fabric it is advisable to cover the print work surface with a draw cloth that can absorb any excess colour and be easily laundered.

Discharge paste is a thickened printing paste that once printed and dried can be discharged (removed) using a steam iron. The paste can be used on either a Procion MX dyed fabric that has been fully washed or a commercially prepared discharge fabric. Discharge paste can also be mixed with a pre-mixed textile colour such as fabric paint, so that colour can be inserted where the dyed colour is removed. This can lead to wonderful effects such as a bright turquoise print being placed into an orange background.

Markal (Shiva) Paintstiks are unique in the world of fabric colouring, and are essentially oil and wax paints in stick form. Markal is a rich, smooth medium that applies easily to all fibres by direct application. Once fully absorbed into the fabric, usually after about 48 hours, it is heat fixed by ironing for four minutes. These chunky oil and wax crayons in a stout card sleeve are available in 50 pure professional colours, 2 metallic colours and 13 iridescent colours. See page 67 for further details.

FABRIC PRINTING MEDIUMS

Type/Name	Description	Use	Qualities	Fixing	Fabric Type
Fabric paint (Textile paint) Jaquard, Pebeo, Javana, Dylon, Colour Fun	Commercially produced ready-mixed pure colours. Jars, bottles, some colours in bulk.	Ready for use directly from bottle – print, stamp, paint, screen etc. Firm consistency, not runny.	Good on white or light fabrics. Addition of white will give opacity if working on coloured ground. Use fluorescent colours to give additional highlights.	Usually heat fix either by ironing or by heat fixation in domestic oven. See manufacturer's instructions for precise details.	All fabric types.
Fabric paint (Textile paint) Pearlescent or iridescent Lumiere	Commercially produced ready-mixed iridescent/pearlescent single or dual colours. Jars, bottles, some colours in bulk.	Ready for use directly from bottle – print, stamp, paint, screen etc. Slightly firmer consistency. Excellent on dark fabrics.	Can make fabric slightly stiff if a number of layers printed. Clean blocks and rollers quickly. Has tendency to adhere.	Usually heat fix either by ironing or by heat fixation in domestic oven. See manufacturer's instructions.	All fabric types – best on darker fabrics.
Markal/Shiva Paintstiks Professional colour range	Commercially produced ready-mixed professional (pure) colours in an oil and wax stick.	Ready for use (break skin). Suitable for rubbings and direct application. Colours vary from transparent, slightly opaque to tints.	Excellent on light and tinted fabrics. Rich pure colours.	Usually heat fix either by ironing or by heat fixation in domestic oven. See manufacturer's instructions.	All fabric types plus suede and leather.
Markal/Shiva Paintstiks Iridescent colours	Commercially produced ready-mixed iridescent colours in an oil and wax stick.	Ready for use (break skin). Suitable for rubbings and direct application.	Excellent on dark fabrics. Rich iridescent colours plus gold and silver.	Usually heat fix either by ironing or by heat fixation in domestic oven. See manufacturer's instructions.	All fabric types plus suede and leather.

Type/Name	Description	Use	Qualities	Fixing	Fabric Type
Printing colour *Binder and liquid pigment* (Screen colour) with **standard binder**	Produced in bulk form. To use, mix intense liquid pigment with standard binder.	Pigments and binder sold separately. Mix colour to desired intensity.	Initial investment but gives flexibility for quantities and colour selection. Standard binder is transparent when used on neutral-coloured fabric.	Heat fix following manufacturer's instructions.	Usually all fabric types. Occasionally special additive for synthetic fabrics.
Printing colour *Binder and liquid pigment* (Screen colour) with **opaque binder**.	Produced in bulk form. Mix intense liquid pigment with opaque binder to make opaque colours.	Pigments and binder sold separately. Mix colour to desired intensity. Interesting effects achieved when standard binder is printed across opaque colour.	Initial investment but gives ability to create layers in print effects. Specialist binders sometimes have limited shelf life. Good on coloured fabrics.	Heat fix following manufacturer's instructions.	Usually suitable for all fabric types. Occasionally special additive for synthetic fabrics.
Printing colour *Binder and liquid pigment* (Screen colour) with **pearl binder**.	Produced in bulk form. Mix intense liquid pigment with pearl binder to make iridescent and pearlescent colours.	Ability to create different levels of iridescent colour from lightly tinted to intense pearlescent colour.	Good on dark fabrics and with transparent colour for layering. Pearl binders have a limited shelf life.	Heat fix following manufacturer's instructions.	Suitable for all fibres. Occasionally special additive for synthetic fabrics.
Advaprint or **Delta Textile Medium** or **Ormoline binder** plus **lustre powders** such as Pearl Ex and Brusho Lustre Powders	Clear fabric binder suitable for mixing with lustre powders. Use 1 teaspoon of lustre powder to 1 tablespoon of clear binder for average lustre.	Fabric binder suitable for all types of fabric printing. Appears milky when wet and mixed with lustre powders – dries completely clear if thinly applied.	Excellent clarity when dry especially on darker fabrics where lustres are most visible. Good fabric handle when fixed and washed.	Allow print to dry and set for 24 hours. Heat fix with four minutes' constant ironing at hottest heat for fabric or 4 minutes at 140°C (284°F) in oven.	Suitable for all fibres.

Type/Name	Description	Use	Qualities	Fixing	Fabric Type
Ormoline fabric medium and bronze powder	Clear binder specifically designed for use with bronze powders. Mix 1 teaspoon bronze powders to 1 tablespoon of Ormoline. Use immediately.	Suitable for all types of printing. Once mixed will appear cloudy in suspension but will dry to high metallic finish. Always wear mask when measuring and mixing.	Excellent high sheen when printed, medium dries very clear. Particularly effective on dark fabrics. Excellent soft handle when gently washed.	Allow print to dry and set for 24 hours. Heat fix, four minutes at hottest heat for fabric.	Designed for natural fibres but worth trying on mixtures.
Thickened dye Manutex Sodium Alginate	Powder form, needs to be made up into liquid form and added to Procion MX dye powders. See manufacturer's instructions.	Transparent colour suitable for all types of printing onto light fabrics. Quite runny. Wear protective clothing.	Excellent for fine delicate effects, retains fabric quality, becomes inherent in fibres.	Fully dry, heat fix either five minutes at 150°C (302°F) or ironing for four minutes at 120°C (249°F).	Silk, cotton, viscose, rayon, hemp and linen.

CHOOSING COLOUR

Actually selecting a printing colour suitable for your requirements can be quite worrying. Do not be put off by the choice of named manufacturers, types of product and specific effects. The most important thing is to get out the fabric and explore the possibilities. There are bound to be 'failures' but there will also be successes and interesting surprises. Your fabric prints will be unique and some will be very special, with your own personal choice of colour pattern and print.

Right: Screen-printed squares and circles with matt and pearl colour on Japanese ribbed silk, dye painted after printing.

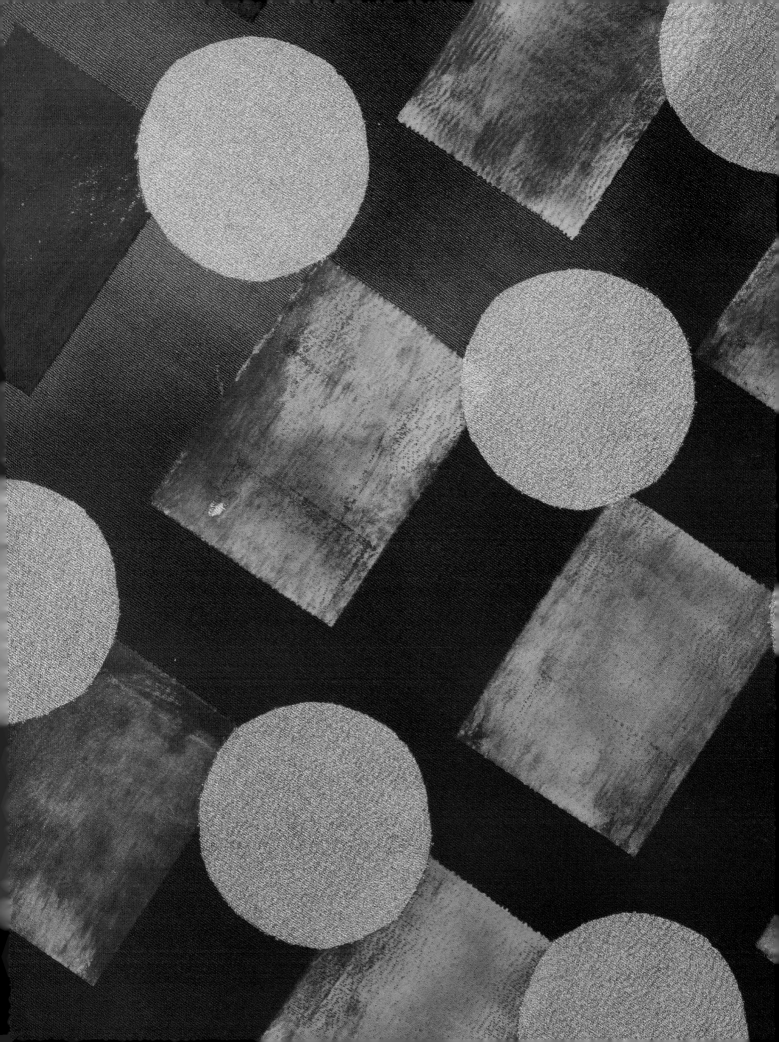

FABRIC PRINTING TECHNIQUES

Many years ago fabric printing was taught in very specific technique 'boxes'. Students were taught to screen print, or block print, or to use specialist dyeing techniques. But more recently there has been an exciting revolution as students and professionals alike have looked to find numerous other methods to create new and individual ways of colouring, patterning and printing fabric.

Most of the printing techniques described in chapter 2 work admirably well on fabric as well as paper – as, of course, does screen printing, which is commonly used for producing printed fabrics with repeated designs. This chapter describes some specific applications of printing to fabric, and also introduces some examples from my own explorations into more imaginative fabric printing ideas. Where special conditions apply to using the print techniques on fabric, rather than paper, they are explained here, as are 'tricks' or effects that work well on fabric. At the end of this chapter you'll find a consideration of different ideas for colour and design that work particularly well on fabric. You should also refer to chapter 2 for information on how to achieve the basic print techniques.

Many of the examples and ideas introduced here are concerned with individual 'one-off' prints, using unique patterns, colours, surfaces and finishes. Each piece is individual even if it is part of a design theme, and each requires special attention to colour combinations, pattern arrangement or fabric finish.

But before launching into complicated and confusing processes, start with simple forays into mono printing onto different fabrics and with different kinds of print medium.

Mono Printing onto Fabric

Mono printing onto fabric is not that different from paper, but it is worth explaining the technique since there are some special points to remember.

Preparation:
Select some prepared plain white fabric (for example, cotton sateen, percale or poplin) and iron it flat before pinning it onto a lightly padded surface.

Equipment and materials:
• Three pots of fabric-printing colours, such as golden yellow, turquoise and magenta
• Plastic printing sheet
• Print roller
• 2.5cm (1in) household paintbrush
• Shaper brush, tile grouter or other drawing implement
• Newspaper, paper towels, baby wipes, apron

Place the two plastic sheets, print roller, brush and fabric-printing colour on the newspaper,

next to your padded print top surface. Wearing the apron, use the brush to carefully apply fabric colour evenly across one of the plastic sheets.

Since you are going to print from the sheet, be aware of the outer edges of the spread colour – if you spread the colour right up to the edges you will make mono-printed rectangles across the fabric. Instead, thin the colour towards the edge of the sheet to make it 'fade out' and also allow the brushstrokes themselves to be part of the surface pattern and to thin the colour towards the edge of the sheet. You will notice that this printing medium is softer than the acrylic used for paper printing. To create your design, select any of the drawing implements and make a simple line pattern into the print surface (the plastic sheet).

Now, carefully lift the plastic sheet and apply it to the flat fabric. (This is the reverse of printing on paper, where you placed the paper onto the plastic sheet.) Gently press into position, checking the print by lifting one corner of the sheet. Carefully pull away the plastic sheet and review your print.

Repeat this process by adding further fabric printing medium to the sheet and drawing into it again. Finally clean the plastic sheet with water or by wiping it with baby wipes.

Right: Mono print using repeated applications of transparent colour in red, turquoise and lemon.

Below: Opaque yellow, magenta and orange mono-printed then dye-painted with turquoise dye.

Suggestions

The techniques for building prints introduced in chapter 2 are just as relevant here. In addition, here are some extra suggestions on what will work and what might not be so successful on fabric.

Mono printing on a coloured fabric can be effective, but use either a pearlescent fabric printing medium or add white to pure colours. Also, be careful not to print too many layers of mono prints on top of each other, as the fabric will become saturated. A useful trick is to initially print with white fabric-printing medium, then add increasingly greater amounts of colour to it, so that the successive overprints are gradually shaded. Once dry, paint Procion MX dye across the prints and watch the pattern emerge from the layers.

Below: Pink cotton percale mono-printed with opaque yellow and pearl blue Adva-Print colour.

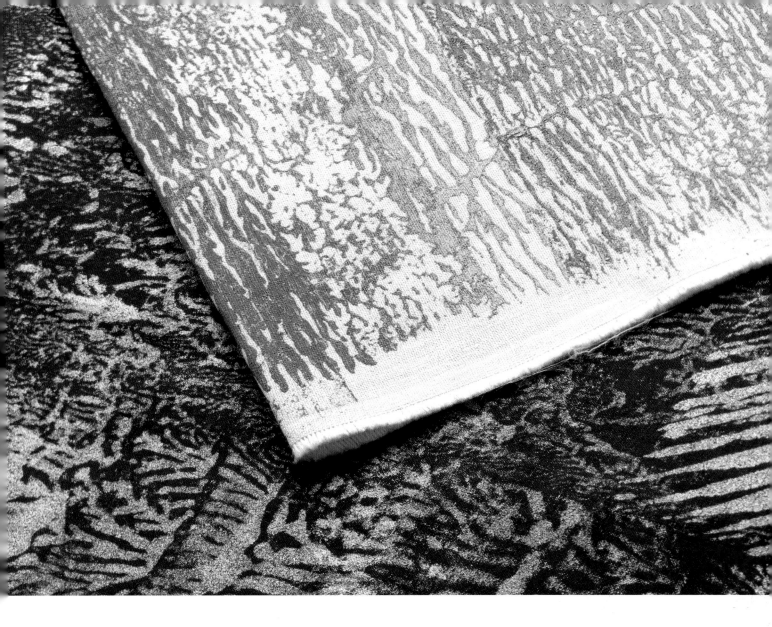

Above: Organic patterns created from a print roller – pearl colour roller-printed onto calico, and bronze powders and Ormoline roller-printed onto Indian cotton.

Alternatively, try choosing a dark fabric and mono print using Lumiere, bronze powders and Ormoline, or lustre powders and clear binder. The effects can be stunning. You can also mono print using an opaque or pearl colour first and then overprint once this is dry with a transparent colour.

The same mono printing techniques using sandwiched plastic sheets work well on fabric. You will remember that once blobs of colour have been spread across one plastic sheet, the two are sandwiched together, causing the print colour to spread out (see page 39).

When you use this method on fabric, apply one sheet to the fabric and very gently stroke the back of the sheet. (If you press too hard the organic fern-like pattern will disappear and become a heavy blob.) You can keep printing until you have achieved an effect that you like.

As before, rotating the sheets before prising them apart, or drawing onto the paint surface with a piece of dowelling or brushes, can bring interesting effects and give shades, tints or colour mixtures. On fabric you can mask areas with masking tape or pieces of paper so that the organic pattern is held within a limited area. These patterns look exceptional when contained as they do not become clumsy and commonplace.

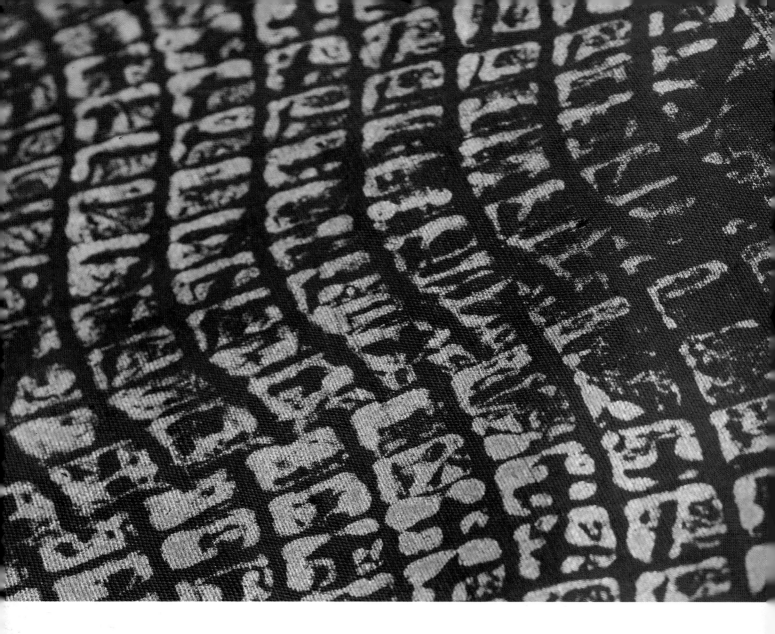

Roller Printing

When printing from a roller on fabric the technique is similar to that undertaken on paper (see chapter 2), but there are certain differences to bear in mind.

Above: Roller print using plastic mesh with light gold powder and Ormoline on magenta Thai silk.

The printing colour on fabric will generally be softer, therefore less fabric printing colour is applied to the roller. Also, the surface of the fabric is very important – the finer and smoother the fabric, the better the printing detail.

When printing, the fabric needs to be flat and reasonably taut, pinned out if possible, so that it is not picked up by the roller during printing. As with printing on paper, if the block or roller becomes too heavily coated it may slip or not rotate. In this case, wipe the roller surface and try again. Fabric colour is much lighter than acrylic and you may find that your print roller does not rotate easily. Do not panic; simply lift the roller and gently pull it through the fabric printing colour. Do this a few times to get the roller rotating and covering the full roller surface. The print roller will possibly create little rippled lines in the printing colour, which is just the viscous nature of the print colour. Sometimes it is possible to print these ripples directly onto the fabric, particularly when using Ormoline and bronze powders.

While you are printing, observe how the fabric printing colour is absorbing into the fabric. Sometimes the fabric is greedy and takes all the colour in the first rotation, but other fabrics may allow three or four rotational prints.

Below: Print with 'found objects' – Lumiere on black polyester cotton using a hot-tub cover.

Try using different rollers, both types and widths, to give pattern variety and quality and, as with printing on paper, experiment with found objects and different textures. You will find that the most unexpected and variable patterns occur when using a print roller in conjunction with an unusual surface or print block.

Try printing with bubble wrap, hot-tub cover, plastic mesh or corrugated cardboard. Prepare your print area as before but include a more resistant rubber print roller to transfer the pattern from the found object. (See chapter 2 for more information on using found objects).

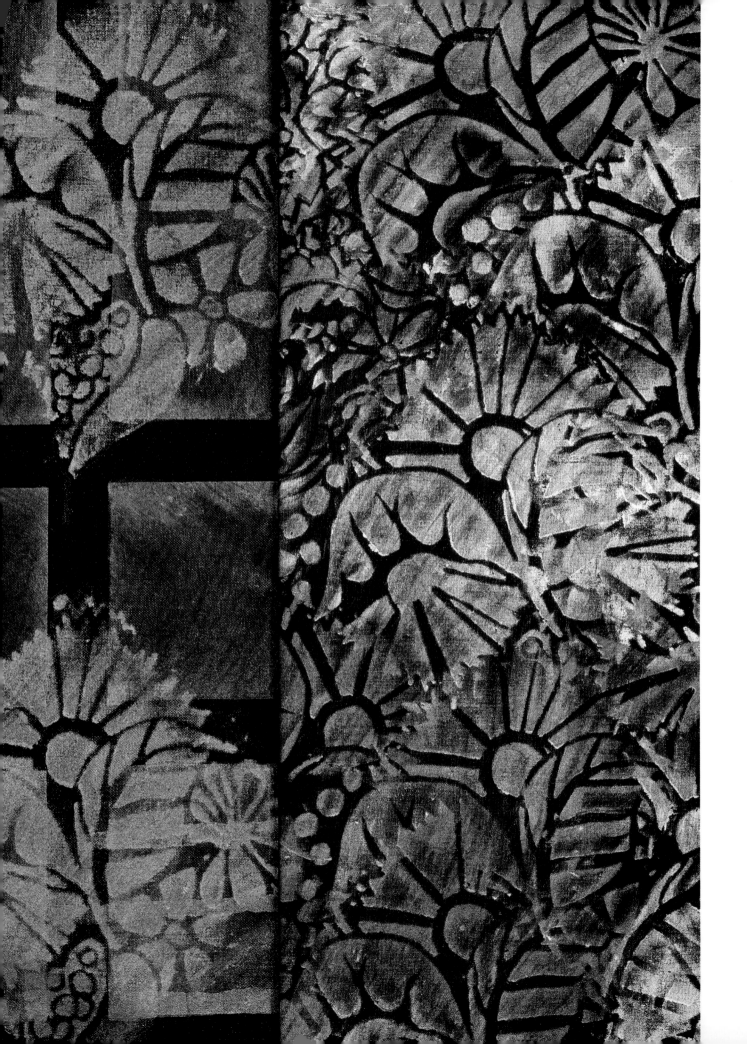

Patterning with Markal (Shiva) Paintstiks

Markal (or Shiva) is unique in the fabric-colouring world, and is useful for highlighting edges of print or to create simple structural lines; it is particularly effective when used with masks to give additional emphasis and definition to patterns and prints. Markal can be applied to all fibre types, although smooth, flat-faced fabrics are best for rubbings (see below). But it can also be rubbed successfully into quite coarse surfaces, such as linen or fine corduroy as well as leather and suede.

COLOURS

As described on page 53, Markal is available in a wide range of colours. In the professional range, certain colours appear more opaque and some colours are obviously mixed with a white. The slightly opaque colours are Azo Yellow and Orange, Cadmium Yellow, Cobalt Blue, Mauve, Napthol Red, Tompte Red, Turquoise, Yellow Citron and Yellow Ochre.

The following colours are tints: Antique White and Titanium White, Beige, Dusty Rose, Ice Blue, Light Green, Medium Pink, Mudstone, Peach, Sandstone, Slate Blue and Wedgewood Blue.

Other professional colours can be blended together using a brush so that lovely rich hues can be created, especially when blended with white. The two blending sticks are not necessary when blending on fabric, and if anything they make the fabric rather oily – it is easier to blend colours using a toothbrush.

BRUSHING METHOD

- Tape or pin the fabric taut onto a firm surface and mask off the area that you wish to add Markal around.
- Break the skin from the Markal and rub it onto the mask, near the edge.
- Using a toothbrush, brush the Markal away from you into the fabric surface. Keep brushing the colour into the fabric until it has reached the density you require.
- Check the level of colour by lifting the mask.
- Markal can be brushed over a previously printed area, infilling areas or enhancing colour. It can also be brushed to give shaded, blended and pure colour effects.

RUBBING METHOD

Using this method, pattern can be applied by using Markal rubbed over a raised surface, such as a print block. Some Markal colours are less oily than others, and give exceptionally crisp rubbings. The following colours are recommended: all iridescent colours (including gold) and professional colours that have an opacity, such as Azo Yellow, Azo Orange, Napthol Red, Light Green, Titanium and Antique White – to name a few.

- Stretch the fabric taut onto a board, leaving one edge without tape.
- Carefully slide a carved print block, crisp textured surface or a string block under the fabric (see page 26–32 for a few ideas).
- Remove the sealing skin from the Markal, making sure that the whole top of the stick is flat and accessible.

- Gently but firmly stroke the Markal across the surface of the fabric, making sure the block pattern is complete. For a flat application of colour, make sure that the Markal stick is at right angles to the fabric. Apply the strokes evenly, working in one direction – don't scrub the colour on. Try mixing more than one colour – simply change colours during rubbing.
- Move the block to a new position under the fabric and use the Markal again.

FIXING

Once you have applied Markal, leave it to be absorbed into a fabric for at least 48 hours before heat fixing the fabric by ironing it at the hottest heat for four minutes. If necessary use baking parchment to protect the iron.

Right: Markal/Shiva rubbing over floral block using professional and iridescent colours and then dye-painted.

Below: Markal-rubbing method – rubbed over cut print block on dyed viscose satin.

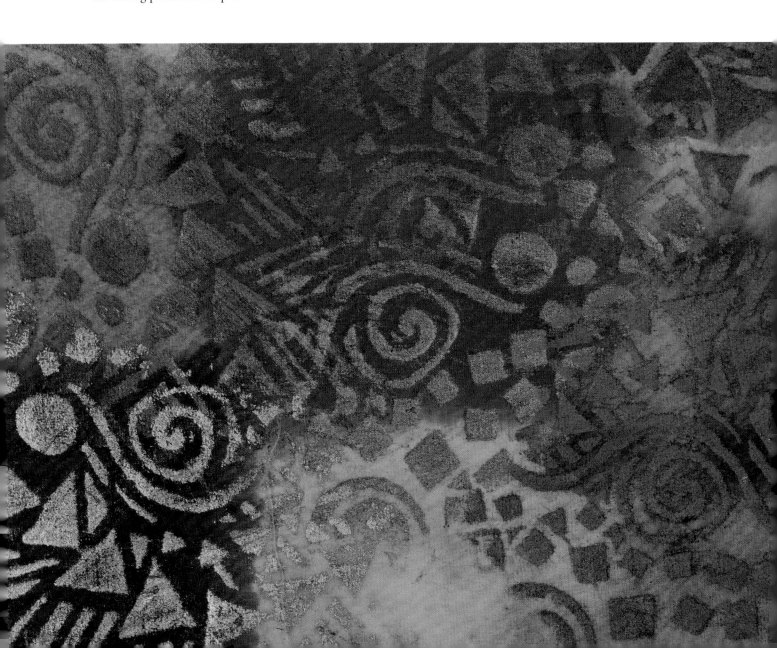

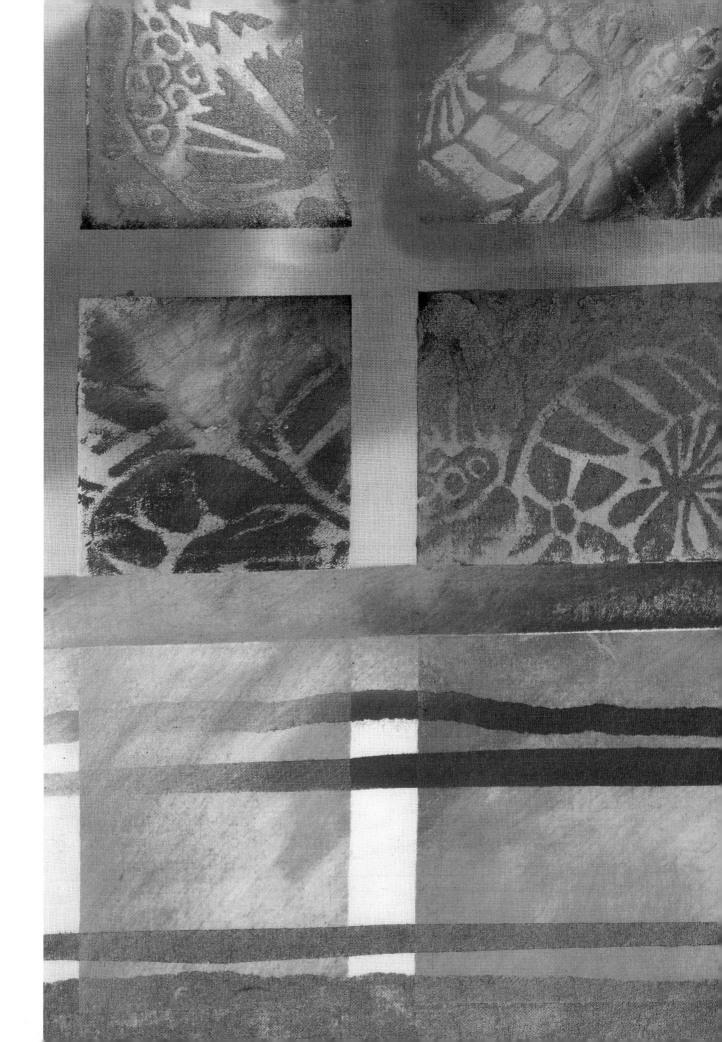

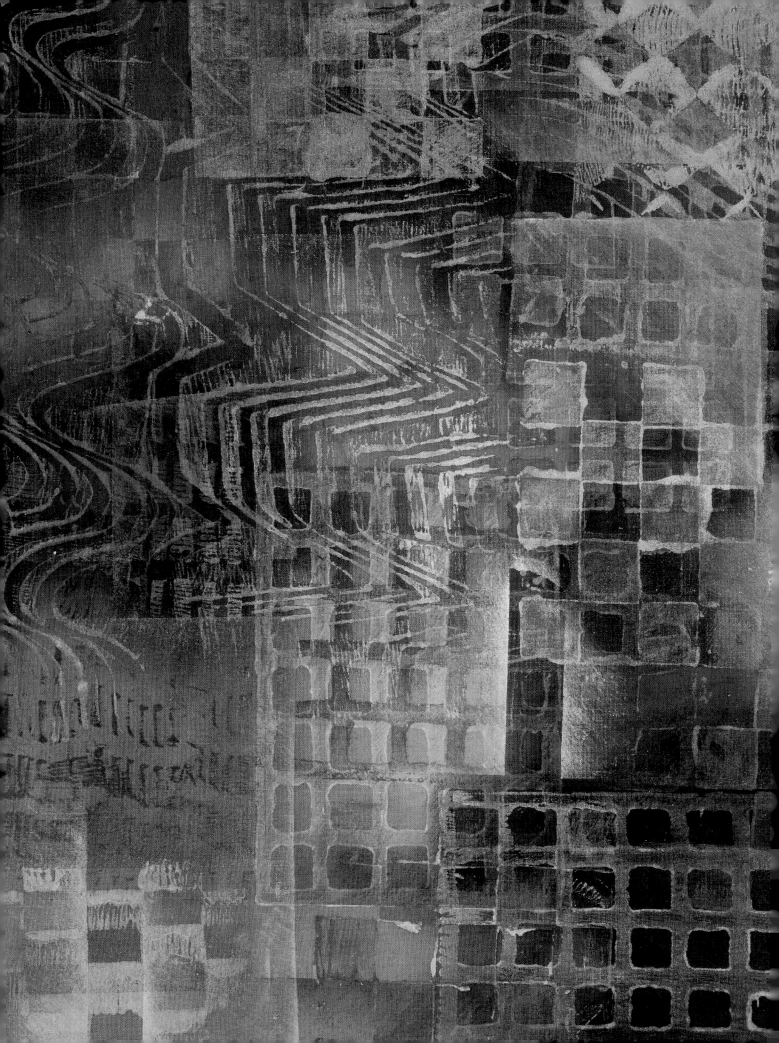

Left: Markal used to
enhance a block print
and a monoprint.

Right: Markal
application using
brushing method –
colour bands on cotton
calico from torn
masking-tape strips.

Masks

Masks are extremely useful when a defined structure is required or a print is located within an isolated area. They are also very helpful when a design requires greater definition or certain features need extra emphasis. In addition, you can use them to protect areas of pattern, voided areas or plain areas of fabric.

When preparing a more complex and intricate design it may be necessary to be able to mask an area of the fabric at some point, and there are a number of different ways that you can do this.

Masking tape is available in a variety of different widths and types, from low tack to flexible, which can give gentle curves. Art shops and DIY (home improvement) stores offer a wide and readily accessible range.

Freezer paper is very familiar to quilters. It is a lightweight white paper with a shiny underside, available in a large roll that makes it excellent for cutting large motifs and masks. It is lightly ironed into position with the shiny side downwards, but is easily removable and can be repositioned by ironing.

Frisk film is a self-adhesive transparent film that can be cut and positioned once the backing is removed. It has a low-tack adhesive that can be repositioned easily and leaves no residue. The transparent film is helpful if exact 'lining up' or registration of the design is required.

Above: Flower block print and string block using freezer-paper masks on dye-painted silk cotton.

Right: Masks and simple mono prints: floral and geometric print, plus mono and roller print, divided and overdyed to show the effect of different colourways on prints.

USING MASKS WITH SIMPLE MONO PRINTING

Left: Building block print on orange and yellow cotton, printed with reds and turquoise fabric paint.

Above: Block and roller print using metallic and lustre paint on black cotton.

By nature, mono printing is a somewhat random and spontaneous technique. It is impossible to consistently reproduce exactly the same pattern or drawn mark, and the area of the printing sheets are limited so joins and overlaps occur. But by preparing and planning a print that is divided by masked voided areas you can combine elements of a print, giving it some sense of structure without losing spontaneity.

Prepare the fabric for printing by stretching it out firmly. Next, draw and then cut out the shapes that you wish to use as masks. You can use freezer masks (which iron on), masking tape or Frisk film for this purpose. When you position the masks, remember to space them in relation to the width of the printing plate that you are using.

Now prepare the fabric printing colour and have all printing materials available on an adjacent workstation. Make sure you have additional cleaning materials handy.

Use any mono-print technique you wish, remembering to ensure that the print colour goes well across the edges of the mask (or masks), otherwise the voided area will appear ill-defined when the mask is removed.

Allow the print to dry, review and if necessary reposition the masks and print again. Once you have printed you can add additional painted colour or use Markal Paintstiks to add definition to the edges of the voided shapes.

This method of printing is particularly effective with thickened dye when layers of transparent colour are overlaid. When the masks are removed they reveal unprinted areas of light fabric showing through that help to give overall structure to the printed surface. Printing on a dark fabric using iridescent print colours, either mixed from lustre powders or from ready-prepared fabric paints, can also be very effective using masks. After positioning the masks, use block and roller techniques to print the fabric. When printing is complete and dry remove the masks to reveal the dark voided areas.

Above: Thickened dye – repeated multiple mono prints on silk dupion.

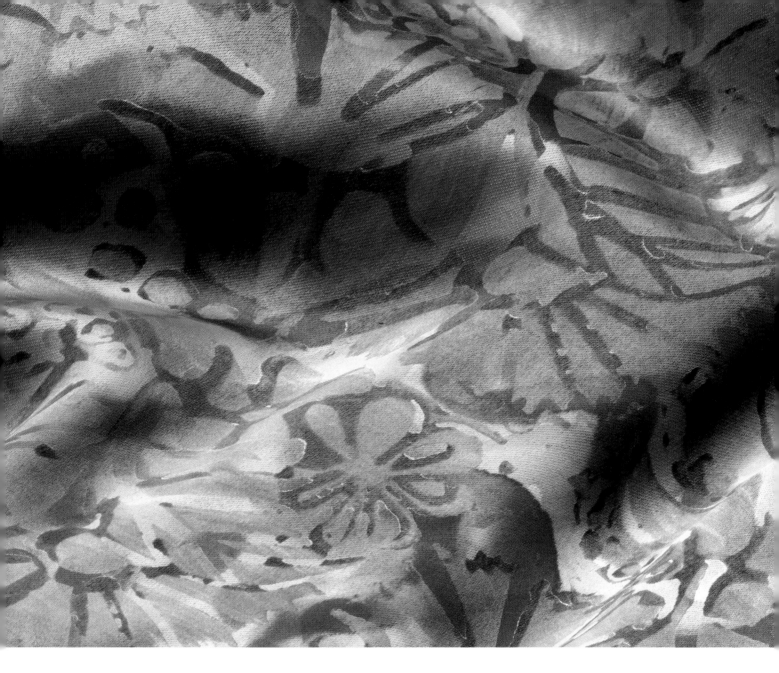

Using Discharge Paste

Discharge paste can be used on fabric to give unusual effects by not only taking away colour but also adding it in different degrees. Sometimes these slightly more subtle and less predictable processes are excellent combined with printed patterns. The actual process of using discharge paste in fabric printing is fairly straightforward, but using it sensitively and imaginatively can give something 'extra' to a finished fabric.

When using discharge paste, it helps to keep certain points in mind. Firstly, discharge paste must always be used on either Procion MX dyed fabric or specially prepared discharge fabric. Once you have applied it, allow it to dry before discharging it with a steam iron. Once discharged the original fabric will be bleached. However, colours vary, with some fabrics bleaching back to off-white while others only lighten slightly. Heat-fixed commercial fabric paints can be added to the paste to give a colour exchange. For instance it is possible to place a bright transparent turquoise into an orange fabric or a bright red into black discharge velvet.

SCREEN PRINTING

Screen printing is a very specific and useful technique, often associated with fine line detail, overprints and complicated processes. In screen printing the design is attached to the 'silk' screen mesh, and a rubber or plastic squeegee blade is used to force the print medium evenly onto the fabric or paper. It was originally called silk screen printing because the framed screen through which the paint is pressed was stretched with fine silk organza; today screens are stretched with synthetic fabric.

Many people are wary of screen printing as it seems to be a very precise and complicated process. In some ways this can be true, but with imagination and a bit of practice screen printing is a very rewarding technique that can produce excellent results. The pros and cons of screen printing are worth considering before you decide to explore this technique. In general, most screens are by nature quite large and bulky, and you will need space and facilities to use and then clean them. For example, even a smaller standard-sized screen is difficult to rinse in a domestic sink. Screens are also quite fragile and the mesh can be easily torn or damaged.

Although one of the advantages of screen printing is that a larger area can be printed comparatively quickly, this in turn requires a larger printing area. Certainly you will require a bigger space than your kitchen table. This is necessary because the frame needs to be moved from one area to another without being placed on the wet print that has just been created. You will also need fairly large quantities of printing colour. These are not expensive to buy, but can deteriorate if stored for long periods of time. However, if you do have space and want to produce larger pieces, then screen printing is an excellent method of creating large lengths of printed fabric at a very reasonable cost.

Right: Screen print – diagonal stripes printed from a screen (paper stencil) onto dye painted viscose satin.

Using Stencils

Stencils are a very effective and simple screen printing device. They can be used as a central pattern or to provide interest and texture in a background, and you can either buy ready-made stencils or make your own. Prints created from stencils can have crisp edges with comparatively fine detail, and designs can be made using one repeated pattern or shape or by using a number of stencils, each printing different parts of the design.

When used in other types of printing and patterning, stencils can provide interesting surface pattern, especially if the stencil design contains detailed textural areas. Designs can be brushed, stippled and sponged to give a variety of different tones and textures to the finished result. In general the colours used need to be quite thick in consistency, for instance tube acrylic or thick fabric paint. Markal (Shiva) Paintstiks can also be applied through stencils.

You can use a simple stencil sheet or translucent acetate sheet to design and cut your own stencil with a craft knife, or you can make a paper stencil. Paper stencils are actually remarkably sturdy. They can be used repeatedly, and will even withstand being removed from the screen, dried and used again for another colour.

Making a Paper Stencil

Select a good-quality cartridge paper of about 130 gsm (80 lb). The paper size must be big enough to completely cover the outside area of the screen, so choose the most appropriate size. Place the paper on the table and place the screen, mesh side down on top of it. Draw around the outer edge of the screen to mark how wide and long it is. Then remove the screen and draw a border *inside* this line by at least 5 cm (2 in): this area will act as the reservoir for the excess print colour, so must not be part of the design. You will draw your stencil design within this inner frame area.

Designing the stencil requires a bit of thought. The type of design must be chosen carefully. For instance, be aware that designs such as squares within squares or circular shapes will fall out of the paper when cut. It is a good idea to start with a simple design, using basic shapes that can be used repeatedly, such as diagonal lines, spirals or leaf shapes. Remember that the design is formed from the areas of space that are cut out of the paper, and it is important to make sure that these form a well-balanced whole. If you wish the design to repeat consider how one print area will join with another.

Once the drawing is complete, tape the paper onto a cutting mat and cut away the printing area with a very sharp scalpel or fine craft knife. Be careful to keep the paper very flat and do not allow it to become creased or damaged. A complex design may require two or three different stencils, with each printing a different colour. In this case, first prepare a master design that contains the whole design, marking which parts are in which colour. Then prepare a traced copy for each part of the design that relates to each colour. Cut each of these out as individual stencils.

Preparing for Screen Printing

You can print onto paper or fabric, but when screen printing onto fabric there are a few special tips that can help you achieve good results. When you start out, choose a relatively smooth-faced fabric; this will help you to obtain a sharp printed line, giving your design good definition. Make sure that the fabric is flat and well ironed, and then pin it as tautly as possible to your printing surface. A fabric with a strong, even warp and weft weave is less likely to stretch and distort when being pinned out, so is a good choice for beginners.

If you want to repeat a design on the fabric, divide the fabric into measured repeat areas and mark them with dark thread or fine masking tape. However, this can be difficult and time-consuming unless a permanently stretched printing surface is available, and in many cases the design can be arranged attractively 'by eye' in any case, giving a greater freedom and a less rigid repeated pattern.

Once you have prepared your fabric, you need to prepare for printing. First, measure the size of the screen-printing area carefully and prepare some blotting papers from newsprint or paper towels. These will be essential once screen printing has commenced, as it is easy to smudge a wet print by placing the edge of the screen on it accidentally. It is particularly important to plan ahead on this when printing in a limited space.

When the fabric is stretched, the stencil cut, and you have both your screen and squeegee ready, you need to collect together the actual printing colour. (See pages 92–93 for more information on different fabric-printing mediums.) It is important to have all the colours ready before you begin printing since the screen mesh can block easily with dried colour if delays occur. Place the print colours in containers on a tray for easy access, along with spoons, a spatula or round-bladed knife, as well as the blotting paper and some newspaper. Finally, put on an apron to protect your clothes. Rubber gloves should not be necessary unless you are printing with thickened dye.

Printing Technique

When you first start screen printing it is a good idea to get someone to help hold the screen firmly in position so that it doesn't shift while you are squeegeeing the paint. Once you are familiar with the printing process it is quite possible to print by yourself.

- Make sure that everything you need is prepared, as above. Now place the stencil design directly onto the fabric and place the blank screen, mesh side down, on top of the stencil. Check that the stencil completely covers the screen mesh area.
- Place the squeegee in the end of the screen nearest to you and pour some print colour between the squeegee and the wooden frame of the screen.
- Now lift the squeegee and place it behind the print colour. With both hands, hold the squeegee at a 45-degree angle and move it across the screen to the far side, gently forcing the print colour through the mesh onto the stencil as you go. Make sure the squeegee is firmly pushed but do not press so hard that the colour is forced under the paper stencil.
- Once the squeegee is at the far side of the screen, lift it up and place it behind the screen colour that has accumulated. Now pull the squeegee back towards you, applying the same pressure. If the fabric is fairly fine, such as silk habotai or cotton lawn, two pulls with the squeegee may well be sufficient. However, thicker fabrics such as heavy calico or cotton sateen will probably require four pulls.

When you have finished pulling, leave the squeegee at one end of the screen and carefully lift the screen and stencil from the fabric together. The paper stencil will stick to the screen mesh and so make it possible to immediately place the screen in the second printing position (assuming that you are printing a repeated pattern using the same stencil design). Be careful to ensure that no area of the screen is placed on a freshly printed area of the fabric, as the colour on the wet fabric will adhere to the underside of the screen and spoil subsequent prints.

Add further printing colour and repeat for the second print. Continually replenish the printing colour as the screen will require a surprisingly large quantity of colour. It may be necessary, as the print progresses, to cover areas that have already been printed, to prevent blots. Use the carefully cut pieces of newsprint to lightly cover the wet prints but remember to remove them as soon as possible.

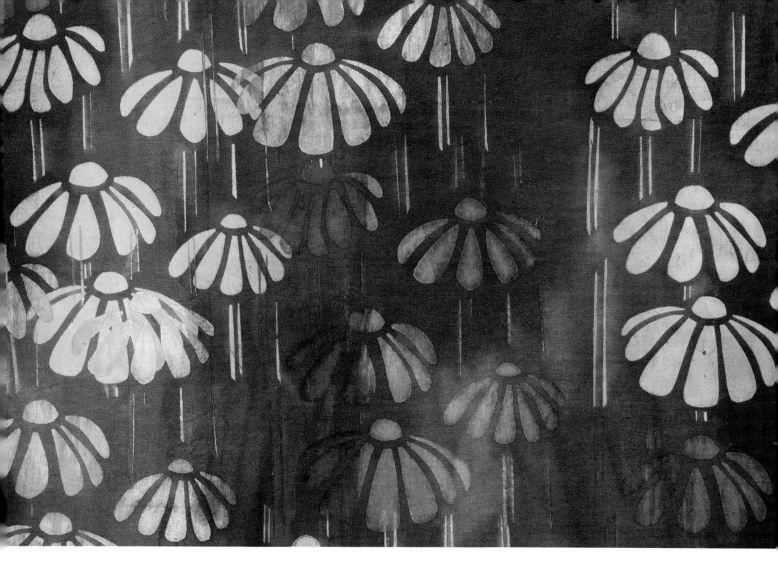

There are quite a few issues to keep in mind when screen printing. To start with, it is very important to plan the order that you are going to place your screen on the fabric, and to arrange this so that you do not have to place the screen onto a wet print. Also, place an extra piece of paper adjacent to the fabric to pick up any printing that 'falls off the edge' of the fabric. This prevents the screen from becoming clogged.

Keep a moderate amount of printing colour in the screen so that the squeegee moves easily with the colour rolling in front of the blade. But do not overfill the screen with print colour as this can gather on the handle of the squeegee, or lie along the edge or side of the screen. Your squeegee technique is also important. Do not press the squeegee down too far, as this will cause a flood of screen colour. Conversely, do not hold the squeegee in too vertical a position, as this will 'starve' the squeegee and give bald and dry print.

Be careful with the screen and always keep it as clean as possible. If you have to put it down when printing, place it on some rests so that the mesh is not in contact with a surface. Do not leave the screen once printing has commenced because the mesh will become blocked very quickly with drying printing colour, and this can create unprinted areas and spoil your work.

Clearing up after printing is also important since both squeegee and screen will not function well unless clean and in good condition. Once printing is finished, use the squeegee or other tools to carefully scrape out the excess print colour from the screen and tip it back into the pot. Then place the squeegee into the sink for rinsing.

Now, carefully remove the paper stencil from the underside of the screen and place it inked side up on a sheet of newspaper to dry. Be careful not to crease or tear it.

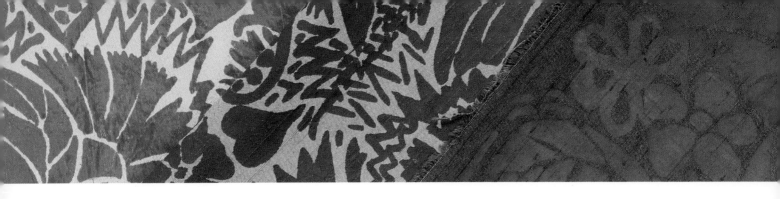

Take the screen and place it vertically in a deep sink. If possible force cold water through the print mesh using a small hose or by rubbing with a sponge. Run the cold water carefully around the edge of the screen to remove any residue that has become lodged under the wooden frame. When the screen is clean, lay it flat on some newspaper and pat dry using sheets of paper. Finally stand it upright to allow the wooden frame and mesh to dry off fully.

Once you have dealt with the screen, wash the squeegee by cleaning it with cold water. Make sure all colour is rinsed from between the wooden handle and the blade, and allow it to dry naturally.

More Stencil Ideas

Paper stencils have the great advantage that the screen itself is left blank, since images are not permanently applied to it. They can also be used to good effect in different combinations. For example, a printed pattern can be made using a number of stencils or by just using one repeatedly. Or several different stencils can be cut using similar shapes or styles of design, and arranged differently on the screen so that the patterns produced are each unique. A single stencil can be used repeatedly on the same print, changing the colour each time or turning the design through different angles on the screen, or turning the stencil upside down. Printing the same stencil twice onto the surface, offsetting the second print very slightly, can provide a nice shadow effect. In all these cases, make sure the first print dries before placing the next.

It is possible to use more than one colour at once when screen printing. Carefully select colours that will mix well together. Position them adjacently in the bottom of the screen when you start and allow the pulling action of the squeegee to gradually mix them together. But do take care when mixing colours. Some colours, such as dark blues, black or strong reds, will dominate, whereas others, such as yellows, white and pastels, will soon become overwhelmed by heavier colour. You can compensate for this tendency by varying the quantity of colours placed in the screen and by replenishing the weaker colours during the printing process. Remember, always add a dark colour to a light one.

Fabric Finishing

Leave the fabric to dry thoroughly in position on the print table without touching it. If a second colour is to be printed, apply it once the first print is totally dry, using a clean dry screen and squeegee. When all printing is complete and the fabric is dry, remove all pins and lift the fabric from the table. Leave it in a warm dry place for 48 hours to fully cure. Finally, permanently fix the printing colour according to the method given in the print colour instructions.

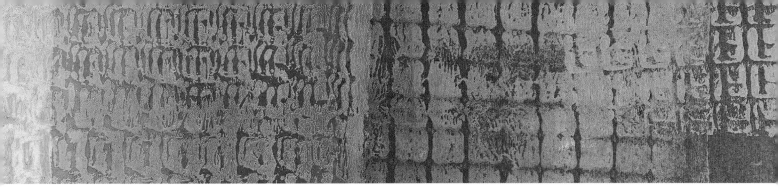

Using a Temporary Screen Filler

Some designs are too complex to be satisfactorily cut as a stencil. A temporary screen filler can be bought for use in this situation, and is a particularly good solution for intricate designs. However it does have the disadvantage that it is indeed only temporary and can gradually degenerate during the printing process.

Applying temporary screen filler:
- Draw your design straight onto the screen mesh before raising the screen on small blocks in a horizontal position to paint on the filler.
- Apply the filler directly to the screen area that is *not* to be printed, using a good selection of synthetic sable round and flat brushes and keep the coating even. If your design is very complicated it is worth using the alternative method of combining screen drawing fluid and screen filler (see below).
- Make sure the screen filler is painted around the edge of the screen and allow at least a 5cm (2in) margin around the design to accommodate the excess printing colour.
- Once the design is painted, wait until it is fully dry before you start to print.

Screen Drawing Fluid

Planning an intricate design by painting on temporary screen filler can be rather difficult, since you are painting on the areas that you do not want to print, and this entails 'thinking in reverse'. However, an alternative method of planning a design involves first painting the areas of the design *to be printed* with the screen drawing fluid, a blue fluid that is easily applied from a brush. Screen drawing fluid is used in conjunction with temporary screen filler as a mask, using the following method.
- Place the screen in an elevated position using small blocks. Paint on the design with the screen drawing fluid and, and when it is completely dry, spread the temporary screen filler across the entire screen. To do this, place the screen on a piece of plastic and spread the screen filler across it with a piece of firm card that is cut exactly to the interior width of the screen.
- Spread the filler across the screen just once and then raise the screen to dry.
- When dry, wash the screen under a cold tap. The blue screen filler will rapidly dissolve, along with the filler that has covered it, leaving the negative areas well coated. As soon as the screen is dry it is ready for printing.
- You can print with your temporary screen filler design just as you would for stencils. But bear in mind that, due to the temporary nature of the filler, you can only do a limited number of prints before the filler starts to disintegrate somewhat, especially in the fine detailed areas of the painted design. Once printing is complete, the temporary screen filler can be removed by vigorous scrubbing and a little abrasive kitchen cleaner.

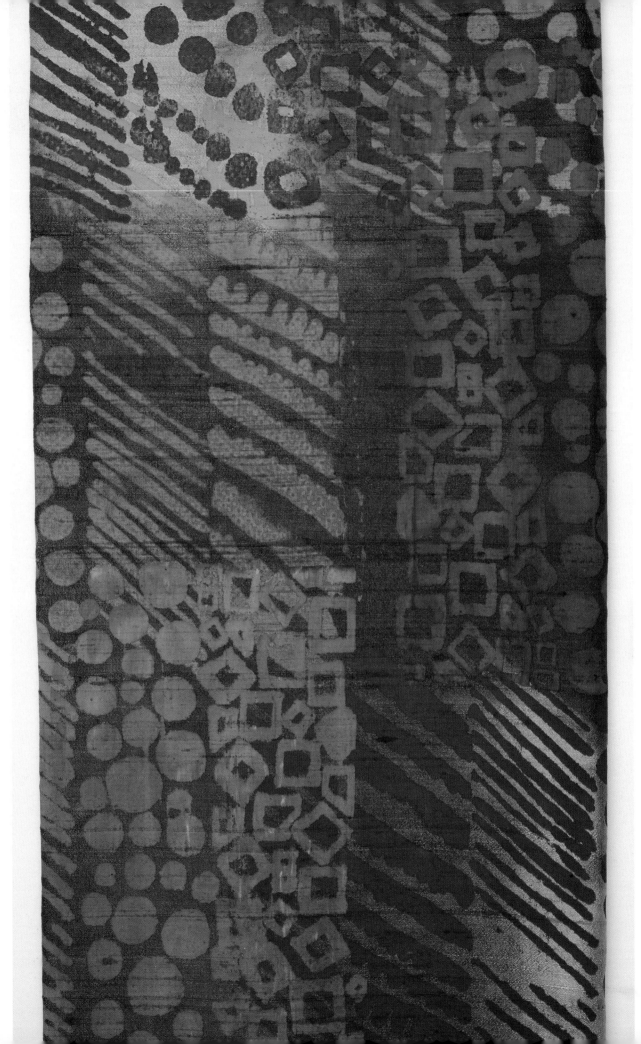

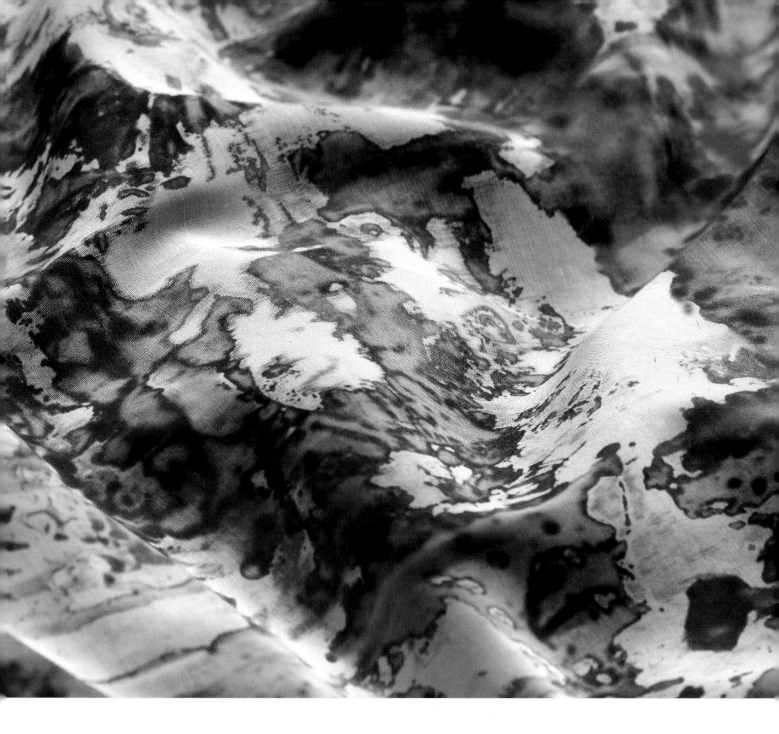

Other Screen Processes

Left: Screenprint created
using temporary screen
filler – squares and lines
printed on dye-painted
silk dupion.

Above: Breakdown print
using thickened dye
(Manutex) on silk cotton.

Recently there have been some imaginative developments in screen printing. These include the use of Thermo Fax screens, small screens with photographically applied images. Another process, called breakdown printing, uses temporary screen blocking from thickened dye that is left to dry and then regenerated by printing with fresh thickened dye, either coloured or uncoloured. The effects are free flowing and less predictable than traditional screen printing, giving a varied colour adhesion and often interesting colour mixing.

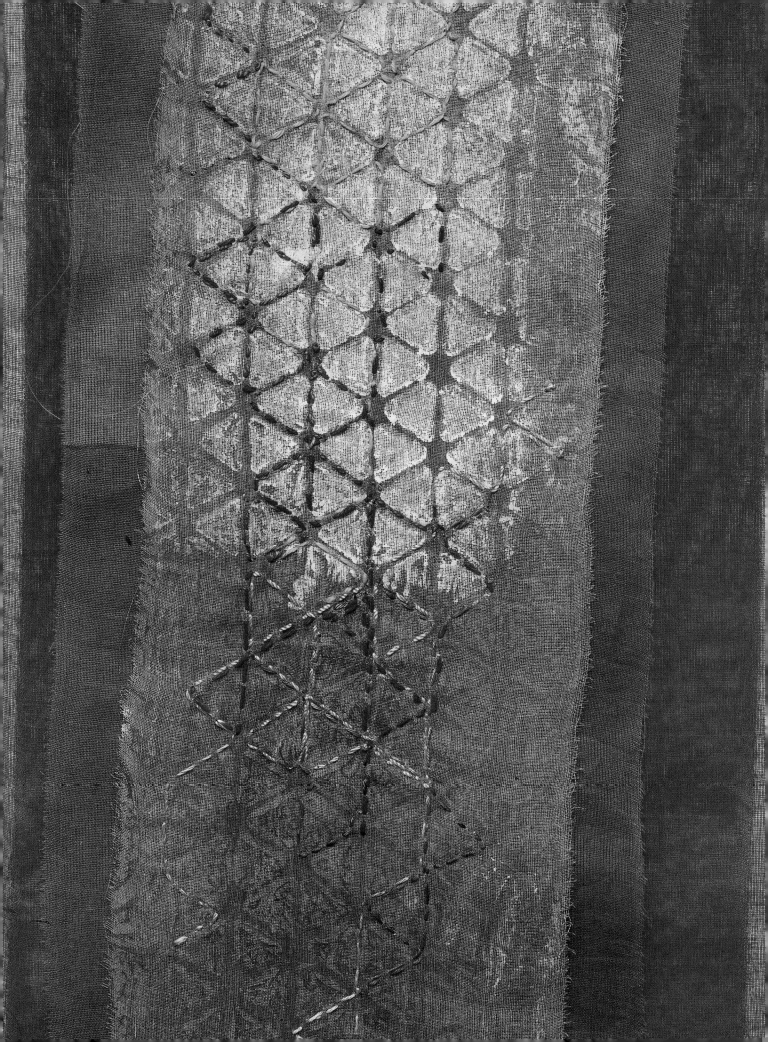

STITCHING AND DYEING

Above: Stitch and print on cotton organdie.

Below right: Selection of fabrics printed with white textile colour and hand-stitched with various natural threads.

Following pages: Dyed fabric stitched with dyed threads.

During my experiments with fabrics it occurred to me that stitching in natural threads onto natural fibres and then dyeing the result would be effective, and I also used this in combination with printing white on white – dyeing the result to bring out both the printed pattern and the stitching. The process is quite simple but the results can be quite amazing. All kinds of clever effects can be achieved by using different fibres, threads and fabrics, as well as by using the white print as a type of resist (that is, resisting the subsequent dye).

So the printing is done on white, onto a white fabric. This is quite difficult because white on white is, of course, difficult to see. It is sometimes so subtle that it is almost invisible. Nevertheless, my investigation led me to discover that it works best on a closely woven smooth fabric or a very lightweight one – unfortunately neither are necessarily the best choice for quick textural hand stitching. Machine stitch is a good alternative but can change the quality of the fabric too much, and machine stitching with thick threads is comparatively limited.

I explored the application of different white print mediums onto fabric, combining it together in a variety of different ways and adding both machine and hand stitch to the fabric. As the work is stitched – either by hand or machine – the stitched pattern, developed from the printing, begins to change and emerge, and eventually becomes quite stunning.

The printed and stitched piece is then dye painted. This must be done gently and slowly, watching the stitches, threads and different fabrics absorb the dye. It is possible to see the dye wick across the fabric or along a thread as patterns develop. When performing this operation there is always a terrible moment when you believe you have ruined your labour of love, but do not despair. Leave the material overnight to dry and rinse to remove the excess dye. Lay the piece flat and let it dry naturally. Gradually, as it dries, wonderful colour, pattern and texture emerge. The different stitched fibres have acted as a conduit, carrying colours across the fabric and giving unexpected colour combinations. The lustre returns to the fabrics and threads and the stitched surface and pattern are subtly visible.

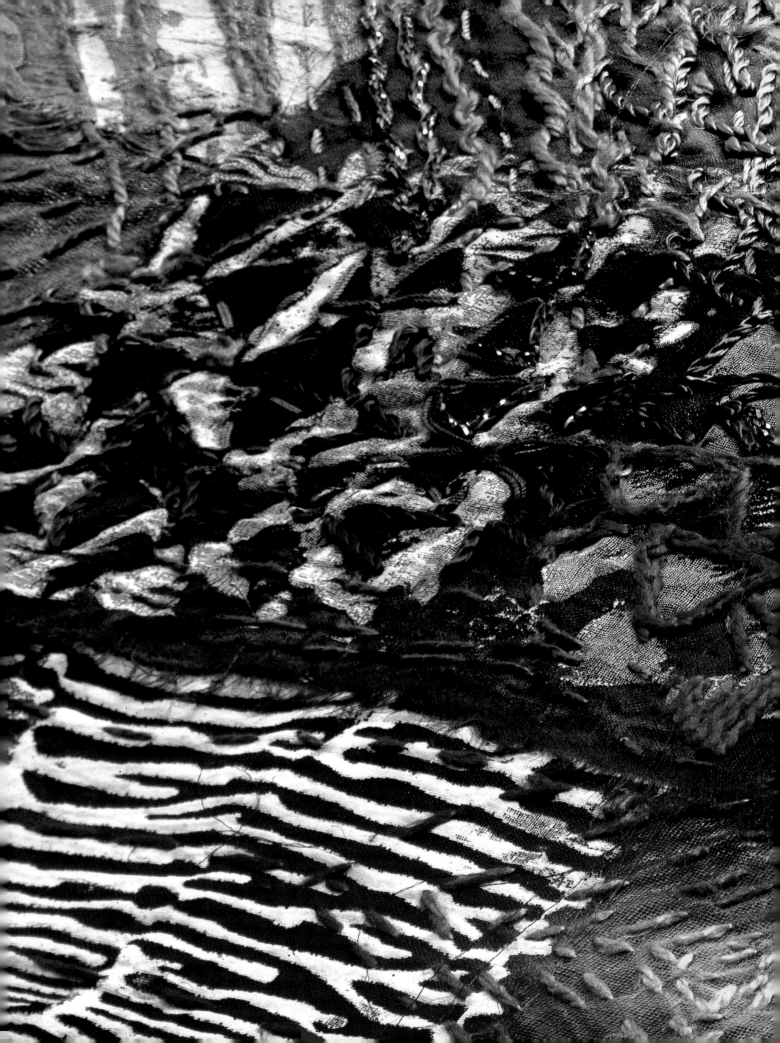

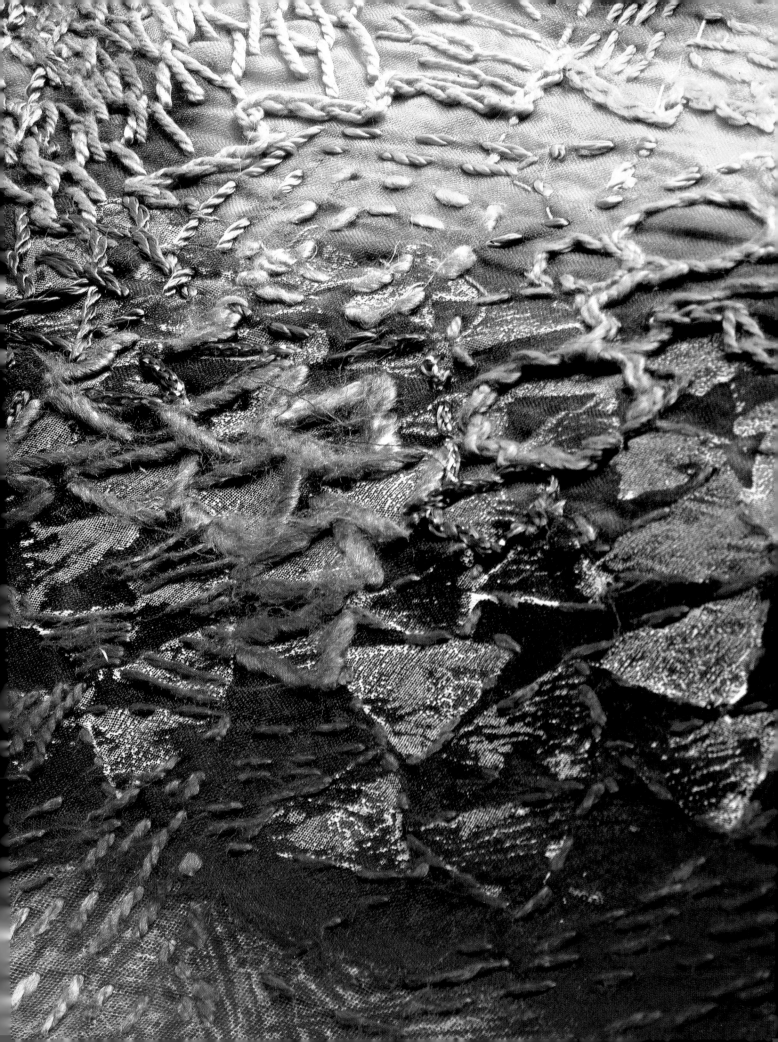

OVERVIEW OF PRINTING TECHNIQUES

Before starting to think more about design, here is a brief overview of the printing techniques available to you, and the qualities they impart to different types of paper or fabric. Remember also that the kind of colours (paints or print mediums) you use will also affect the nature of a finished design, as will the fabric you choose to print on. Always refer to the instructions provided by the manufacturer of the specific brand and type of paint you are using.

Printing Technique	Fabric Printing Medium	Types of Fabric	Suggested Use or Quality	Further Additions
Mono printing or roller printing	Thickened dye.	Natural fibres – smooth weave.	Will retain inherent quality.	Could be a background to further printing.
Mono printing or roller printing	Textile-printing colour, transparent, opaque.	All fibres – smooth surface.	Excellent for spontaneous areas of pattern. Good to use in textile projects.	If printed on natural fibres could be overdyed.
Mono printing or roller printing	Metallic bronze powders or lustre powders and binders.	Black or dark fabric, any fibre, medium to smooth face.	Very exotic. Use for base for machine embroidery, garments, quilts or lengths.	Could be enhanced with Markal, used to highlight certain areas.
Block and roller printing	Textile colour with white added.	Pre dyed colour or undyed natural fabric.	Opportunity to build layers of luminous colour, layering may stiffen fabric.	Opportunity to overdye, allowing print to act like a resist.
Block and roller printing	Pure textile colour to emphasize the variety of print techniques; try shades of one colour.	Very smooth fabric such as viscose satin.	Retains the quality of fabric, useful for garment making, embellishing with stitch.	Try working on sheer fabrics to use in layers for stitch or quilting.

Printing Technique	Fabric Printing Medium	Types of Fabric	Suggested Use or Quality	Further Additions
Block and roller printing	Metallic and lustre powders plus binder.	Especially good on heavyweight black fabric, any fibre.	Combination of high sheen and subtle lustre.	Rich bold effects, very theatrical.
Screen printing	Pure textile colour plus additions of white to give opacity.	Cotton satin, calico, light coloured.	Opportunity to print on larger scale, shade colour or layer colour.	Could print numerous colour combinations on different fabric weaves.
Combination techniques – mono print and masks	Combination prints using transparent, opaque and pearlescent colours.	Any fibre, preferably smooth-faced.	Furnishing, fashion, domestic, quilts, embroidery.	Further enhancement using Markal or dye if natural fibre.
Combination techniques using print blocks and roller	Fabric printing colour using layers of transparent and opaque colour.	Fine, close-woven natural such as cotton satin, poplin or calico.	Garments and domestic use.	Opportunity to dye paint once print is heat fixed.
Markal (Shiva) rubbing and dyed effects	Markal (Shiva) Paintstiks and Procion MX dye.	Cotton poplin or calico.	Decorative effects for furnishings, domestic or fashion items.	Leave 48 hours, heat fix and then dye-paint.
Dye, print and discharge	Procion MX, discharge paste and textile colour.	Natural fibres, cotton, silk, linen, excellent on cotton and viscose velvet.	Rich sumptuous effect, good for furnishings and exotic garments.	Could add further print or Markal enhancement.

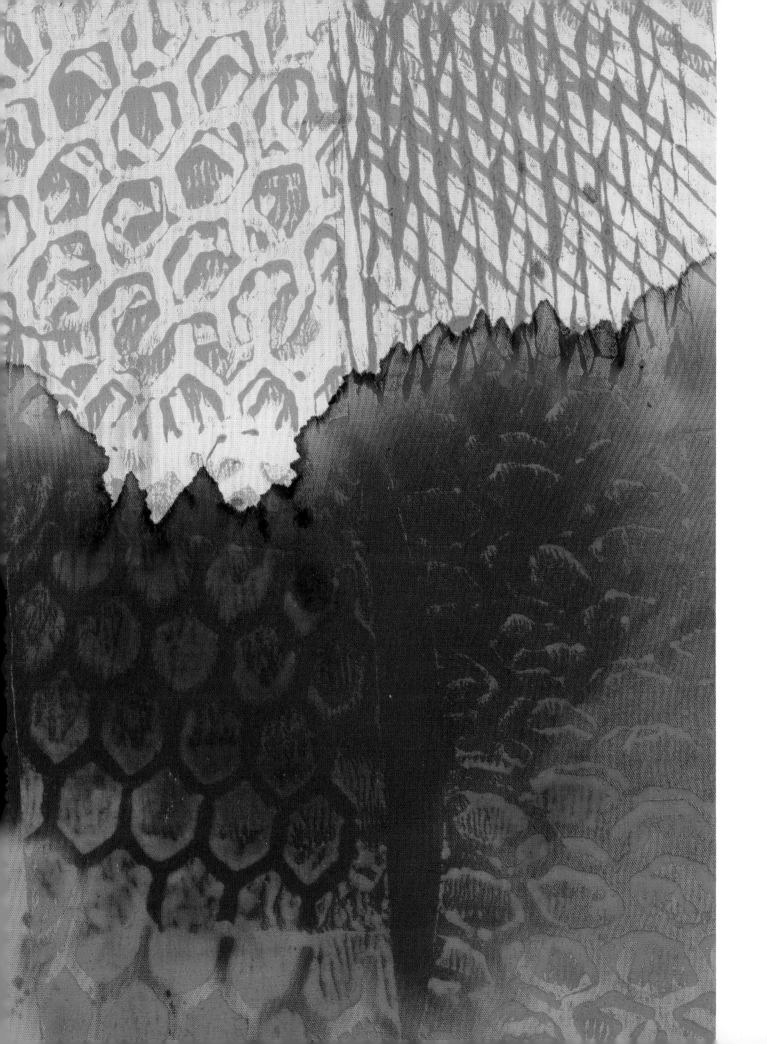

DESIGN CONSIDERATIONS

Unlike printing on paper, printing on fabric often entails printing on quite a large area, using a repeated pattern or design. Variations in the way you apply a printed pattern can give vitality to a large design. For instance, when block printing you can use the same block repeatedly, varying the orientation to print the pattern in lines, mirror images, inverted motifs, half drops, bricks, 90-degree turns or rotations.

You might also print a variety of different blocks and roller images onto the same fabric, with designs connected to a single theme – such as simple geometrics, or leaf patterns. Alternatively, you could build a collection of blocks and imagery to create a series of fabrics around a theme but using different print scales and differing processes and media. Consider using complex combinations of printing techniques such as mono printing, block printing or roller printing. Remember that you may need to adapt design ideas for different fabrics, since an idea that works well on fine silk might not work in the same way on heavy cotton furnishing sateen.

When it comes to colour ideas, the same considerations that apply to paper also influence the finished fabric print. Consider the many options open to you: dark on light, light on dark, tints of a colour by adding white, adjacent colours, mixing complementary colours such as yellows and purples, or even two colours close to each other on the colour wheel – such as orange and red – and a complementary such as a green.

Also think about combining print mediums. Try overprinting transparent colour with standard colours or thickened dye. Or layer different transparent colour and use coloured overprints. Explore the possibilities of layering translucent colour and opaque colour, or printing opaque colours onto strong or dark colours. Consider the possibilities of printing onto a natural fibre, such as cotton or silk, fixing the print and then dye painting the background. Enjoy the sumptuous effects of combining different metallic golds and coppers, or using lustres and pearlescent colours. The use of different print mediums will affect the dye colour, sometimes in unexpected ways. Finally, combine different processes such as dyeing a fabric (perhaps using low-immersion dying) then block printing later.

Left: Small sample tile
spaces roller printed and
dye painted on spun rayon.

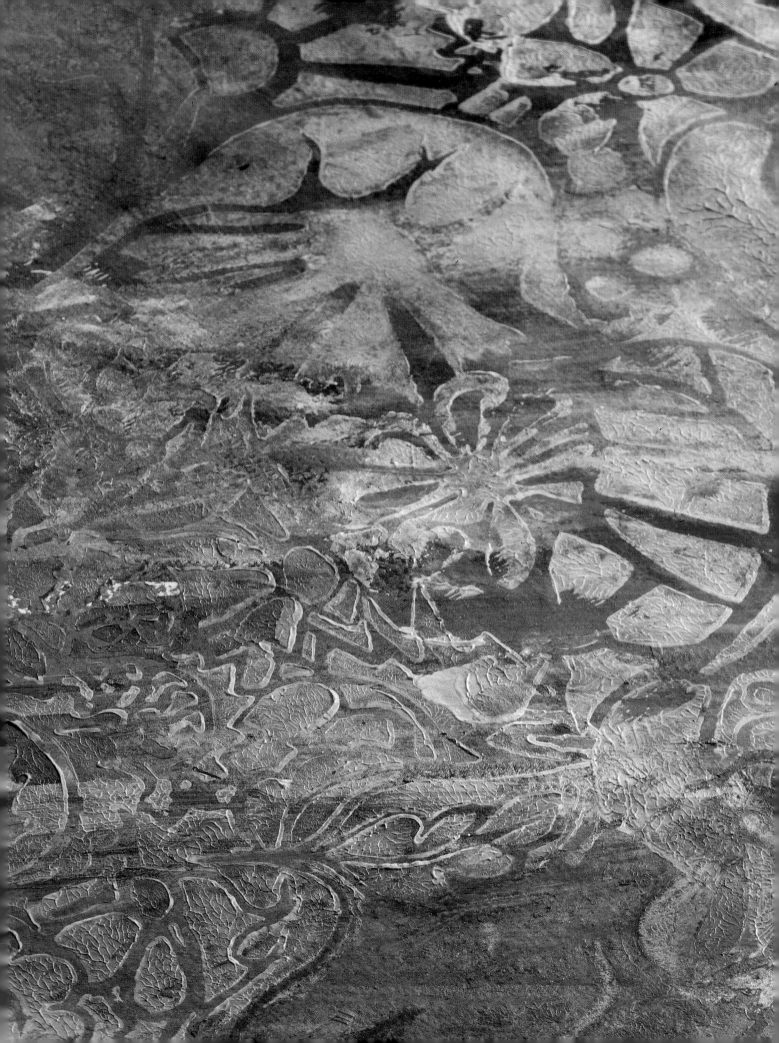

Chapter 4
Design Ideas and Development

Even with a range of print techniques under their belt, many people feel
a bit intimidated by the idea of developing their own designs.
This is quite understandable – translating your ideas into practical
designs requires just as much practice and time as the printing
techniques themselves. It can be frustrating when you think up
interesting abstract ideas but find you can't put them down successfully
on paper because your drawing skills let you down. Don't be put off –
with a bit of perseverance there are many different ways in which you
can develop designs. This chapter provides some simple suggestions that,
with imagination, you can develop into a range of different ideas.

Left: Exploratory block printing using floral
block onto cotton rag paper with Markal
(Shiva). Print was overinked and further
enhanced with coloured crayon.

BUILDING A COLLECTION
FROM SIMPLE BLOCKS

Now that you know the basic printing techniques, I would like to introduce some work of mine that carries them a bit further. I would like to show you how I go about exploring ideas, so that you can see just how much can be done when printing on either paper or fabric with some very basic blocks.

First, I made a collection of about 12 blocks using Funky Foam and foamcore blocks. The blocks were mainly variations on simple geometric patterns, squares and circles, but the spacing of the squares and circles on the block was quite critical. By careful arrangement it was possible to get the smaller spots on one block to print in the middle of large spots previously printed from other patterns. At the same time squares could be arranged as diamonds so that they would fit in the void between squares created from other blocks, or the same block in a different orientation. Soon a whole collection was prepared with blocks that worked well in different combinations.

Below: Square patterns – Pink and orange cotton percale fabric printed with Jacquard textile colour using both block and roller printing.

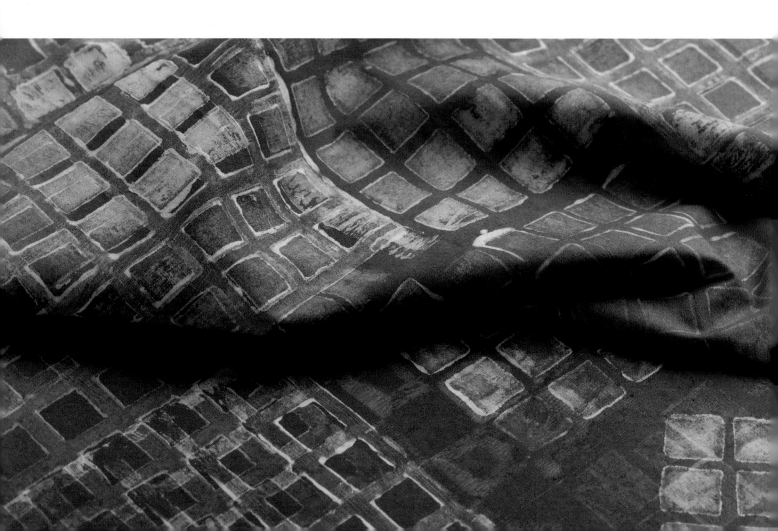

Exploring Ideas on Paper

Above: Black cotton fabric with metallic and lustre powders block printed with square blocks.

I prepared a range of acrylic colour to use with my collection of blocks, laid out the necessary printing equipment and – perhaps the most fun aspect of preparing – gathered together a wide variety of paper. There was thin tissue paper, tracing paper and cotton rag paper that had been previously printed and coloured with Markal (Shiva) Paintstiks, as well as being crumpled. I also collected uncoloured papers, such as uncoloured Lokta paper and white cartridge paper, as well as a range of inexpensive, brightly coloured papers.

Once I had all these materials to hand, I could begin exploring. I began to consider various possibilities and try them out: What would happen if spots were printed in bright colours on other bright colours? Would light turquoise print onto an orange salmon colour? What would happen if bright green was printed next to it? How would those same colours work on a crumpled pale yellow paper? What would happen when the pale turquoise was roller printed across a piece of tracing paper? After I had tried out my ideas I waited until some of the prints had dried and then over-inked them with strong purple and blue mauve, to obtain yet another effect.

The process of exploration was enjoyable and fruitful, so I repeated my experiments with a different range of more muted colours onto a cream Lokta paper. This time the colours I used were more 'earthy'. They were yellow ochre, deep teal, a grey-blue as well as a pale green and lilac. Somehow the colours lacked power, and looked too insipid on the neutral background for my personal taste. Having let the acrylic dry, I painted ink across the paper, and this transformed the colours.

Once I had a selection of prints I cut them into pieces and rearranged them to give me a selection of colour combinations and pattern and print ideas for future reference.

Moving onto Fabric

There were many exciting colour combinations to be obtained from using the same collection of blocks on fabric. One effective technique is printing onto undyed fabric using transparent, opaque and pearlescent colour and then dyeing the fabric at a later stage. Another good combination is a brightly-dyed fabric printed with vibrant colour that has white added – it has an eye-popping 'sizzle'.

In the example shown on page 99, the same blocks have been used on black fabric with metallic powders and lustres that look quite sheer and iridescent.

Once I had a collection of brightly coloured prints in different fabric and colour combinations, and simple geometric mono prints, I sewed them into a child's quilt. For other samples that I had printed on bright cotton organdie I added a simple, coloured hand stitch to finish.

Even after finishing my initial experiments the blocks still have their uses. I use them to give excellent background texture when printed from a roller, or as a fun way to explore proportional colour exercises.

Above: Triangle block print onto dyed viscose satin.

Right: Square patterns. Top: linen block and roller printed and then spray dyed. Bottom: Cotton percale with standard opaque and pearl colour overdyed in mauve.

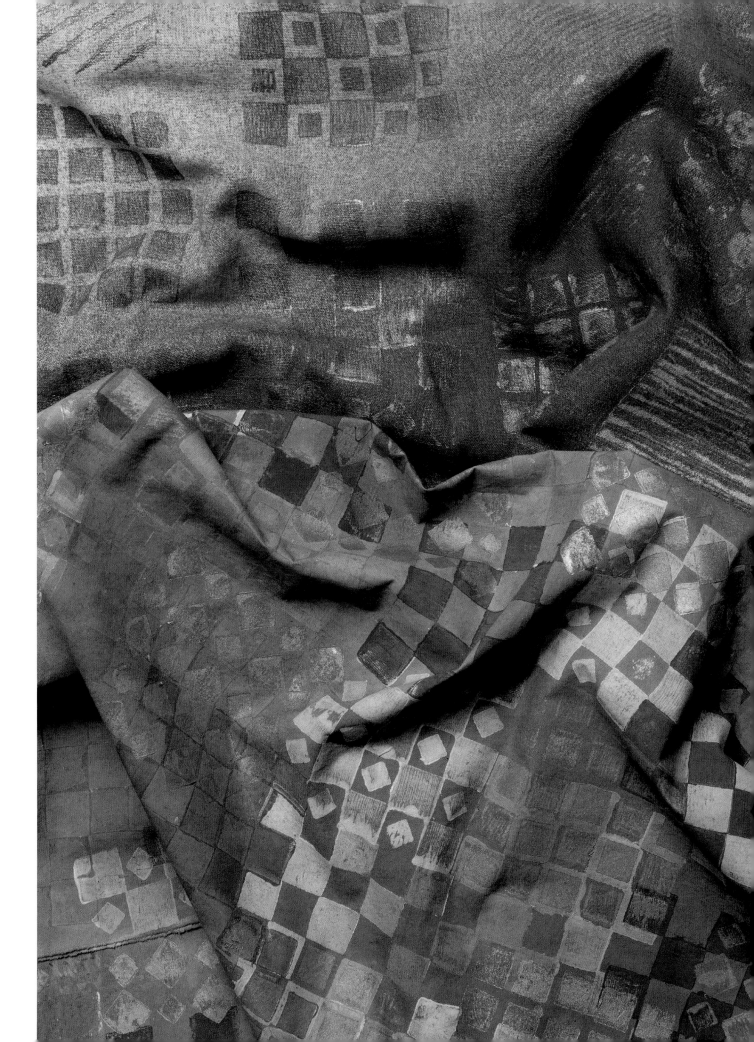

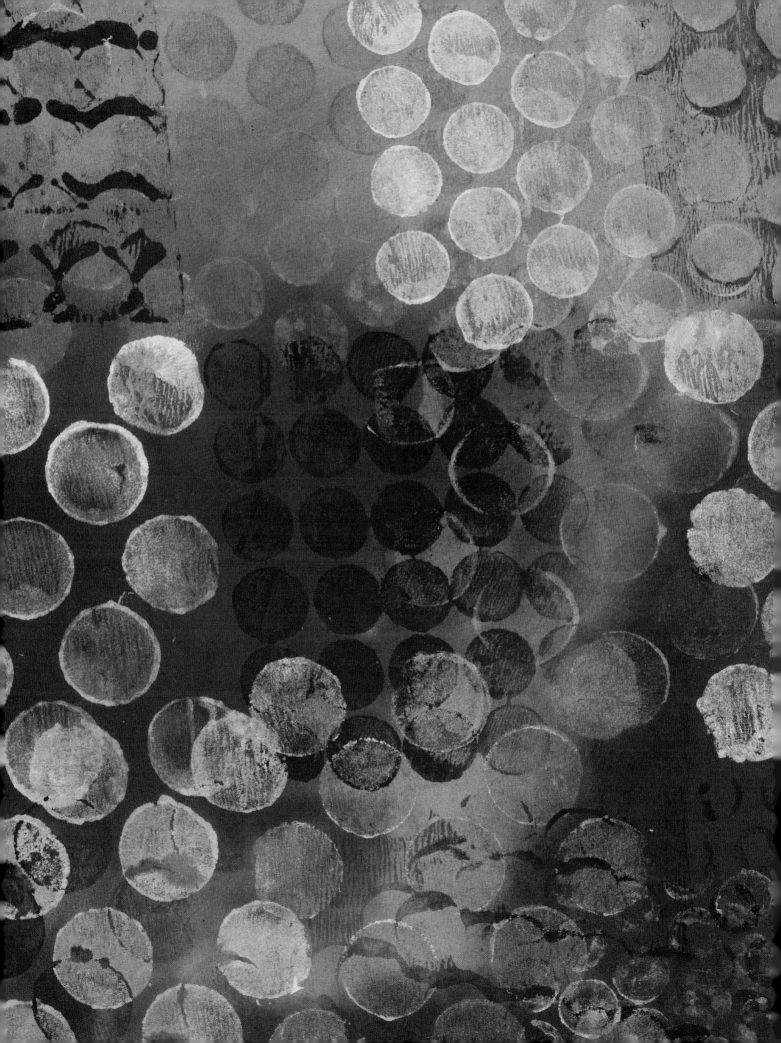

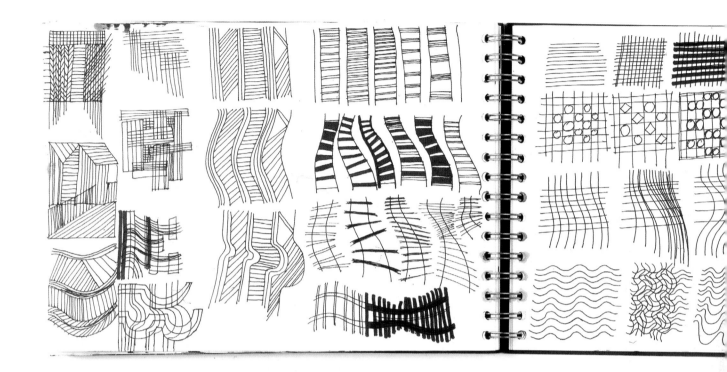

EXPERIMENTING WITH LINES

Even a simple straight line can be interpreted in numerous different ways. Here are just a few examples, although you will certainly be able to think of more:

- Textured line on smooth background
- Patterned line on plain background
- Shiny line on textured background
- Dark line on light background
- Lines made up of fine lines
- Lines made of bold strong lines
- Dotted lines
- Lines made of dashes
- Different colours – thick red on thin yellow, thick yellow on thin red

Line Patterns

Above: 'Just Lines' taken from sketchbook of design ideas.

Left: Spots in bright colours. Jacquard textile colour plus white then dye-painted.

Let yourself explore making all kinds of lines. Some lines may be reminiscent of childhood book illustrations, some of pieces of loose woven fabric. Sometimes the sheer rhythm of drawing will lull you into a creative state of mind, and you may find all kinds of design ideas coming to mind.

There are all kinds of texture combinations you can create with lines. For instance, draw horizontal lines that are roughly parallel, or at least all going in the same direction, keeping them about the same length. Or combine vertical and horizontal lines, with about the same spacing, or alternate thick horizontal lines with thin vertical ones (or vice versa). You can

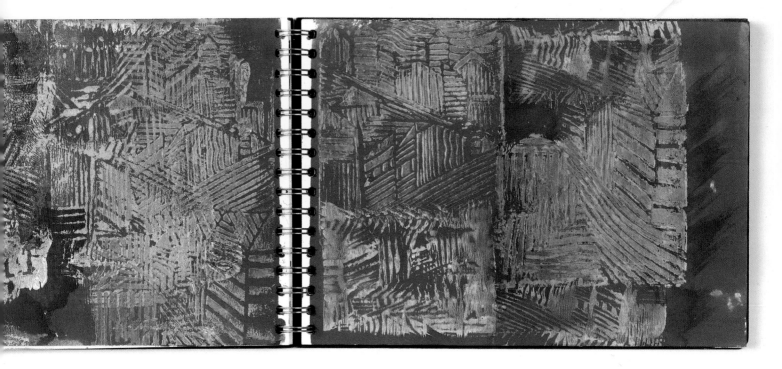

also incorporate diagonal lines. It does not matter if the lines are not accurate or evenly spaced – just enjoy the possibilities. Once you have made some grids with lines you can try putting simple shapes into the squares or rectangles you have created, for instance adding spots, circles or diamonds. Place them regularly or try them scattered, or group them in clusters.

When you have tried out all these ideas, stand back and look at the results from a distance, and see what you feel about the drawings. Consider which textures or patterns could be used together, or as a background to a more defined pattern such as a spiral, floral or geometric shape. Think about what would happen if they were printed in different colours or different thicknesses.

Above: Lines and themes – from building block print in sketchbook of ideas.

Curves and Ripples

Having experimented with creating simple grids with straight lines, take this a step further and make the lines curve. Try to make all the curves move in a similar direction as if they are contour lines on a map, following each other. This will provide a pleasing movement, giving a sense of visual rhythm to your design.

Now try making ripples by letting the lines wiggle, curve and wobble, forming wavy patterns. Explore curved and rippled lines both horizontally and vertically and you will find that they quickly become tangled up in fascinating patterns. Once you have finished, view the results from a short distance away, as before. You may well find that your sketches provide all kinds of ideas. Already, simply by using lines, you have the means to build pattern, texture and movement into your designs.

Stripes

So often when stripes are used for fabric, people degrade them by suggesting they are only suitable for deckchairs. But in fact stripes are a very useful pattern and give infinite variety. They are powerful when used in two strong, contrasting colours – such as black and white, or red and white. When a number of different colours and widths are used they can provide everything from rich, ornate textures to fresh, simple patterns.

To experiment with stripes, first draw two parallel lines, some distance apart. These will form a 'frame' for your grid. Now draw further lines at right angles to the first lines, thus making a grid of stripes. Vary the width and the spacing of these lines, perhaps grouping three lines together, then having a large space, then a further three lines and so on.

Try making the first two lines that frame your pattern slightly wavy. Then in-fill with the other lines, still keeping them inside your two lines but manoeuvring them to fit. This will provide a different grid shape. Or you can do the opposite and let the lines 'escape' their frame. If you give them curves and a sense of movement, they can give the impression of dancing, or of being blown in the wind. You can also vary the pen width to give emphasis and contrast to stripes.

Below: Roller print from a tile-spacer block with acrylic on paper, then overinked.

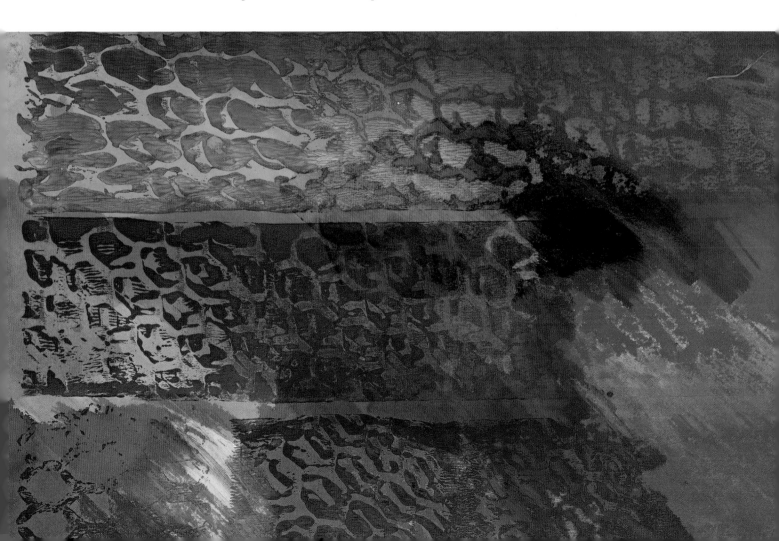

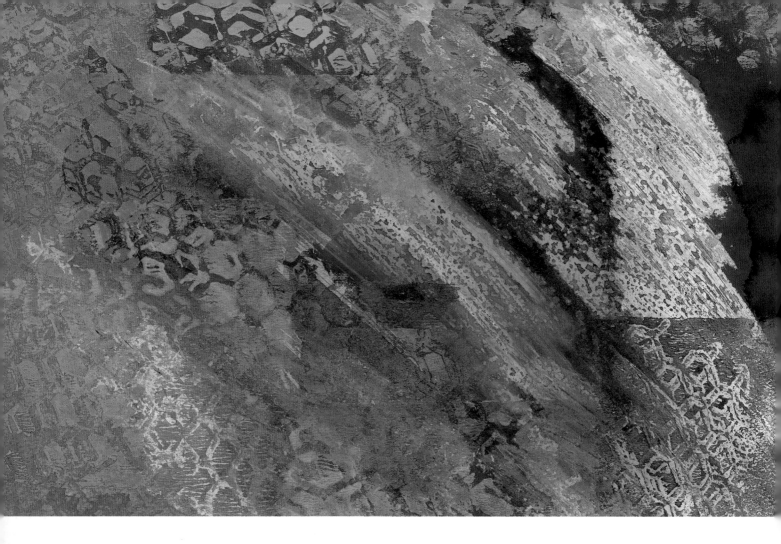

FINDING INSPIRATION

Look around, and you will find many patterns, colours and design ideas in nature. They are there in certain shapes, in manufactured objects, and in the natural repetitions in the world around us. I find now that I see them all the time, and they give me numerous ideas, so you are sure to spot ideas for developing designs this way.

Fields are a great source for line patterns. Look out for arable-farmed fields, or rows of planting in spring, early summer growth with the lines carved by the tractors when spraying. By autumn all this is replaced by the pattern of stubble where the combine harvester has been, but still showing the original planting.

In many countries, wood is an important material for building homes, barns and sheds. The wood cladding (siding) on buildings forms interesting line patterns, and the way the wood is arranged in windows, doors or shutters can also provide fascinating ideas for designs. Similarly, there are lines and patterns to be seen in such mundane structures as potting sheds, beach huts, old wooden bridges or causeways, as well as fencing, railings and grilles.

Next time you are travelling by bus or train, enjoy staring out of the window, seeing rows of trees, planted in order yet each slightly different, varied foliage colour and shapes. Seasonal changes give variations of colour, shapes and textures.

All these ideas can be interpreted into simple line patterns and, although the end results are abstract patterns, they will still remind us of familiar things around us such as buildings, plants or fields.

Above: Roller print from Y-shaped-tile-spacer block using acrylic and Markal (Shiva) rubbing with further overinking.

Right: Roller print taken from kebab-stick block in turquoise acrylic, further inked with scarlet, magenta and golden yellow.

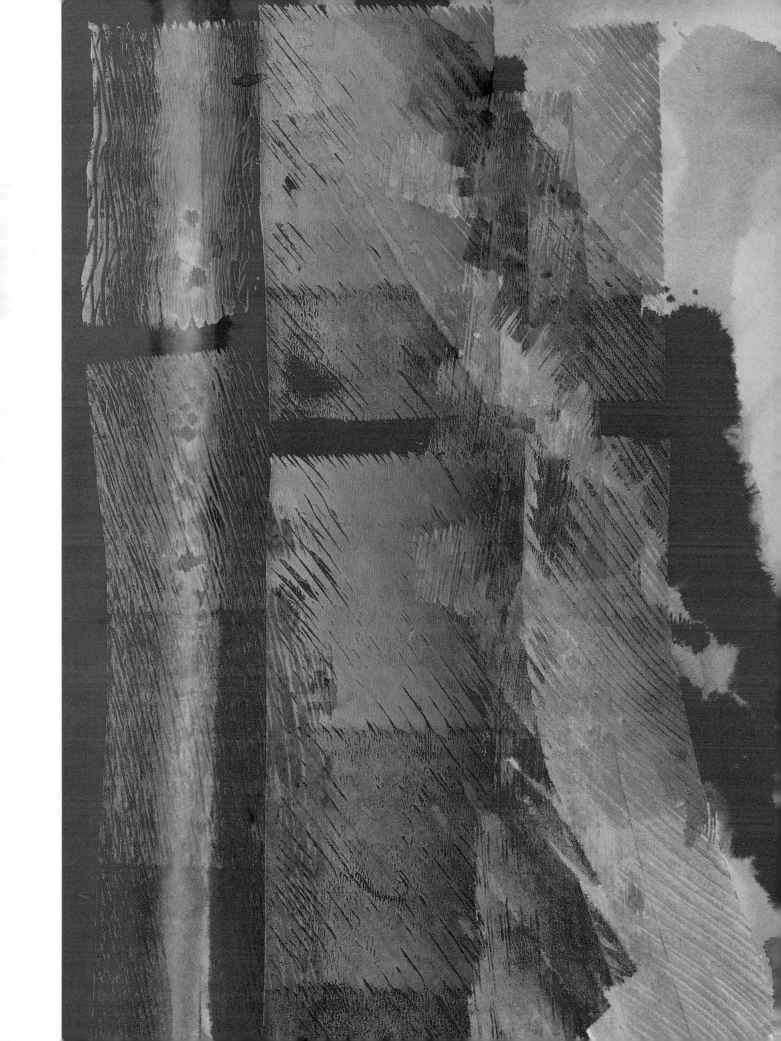

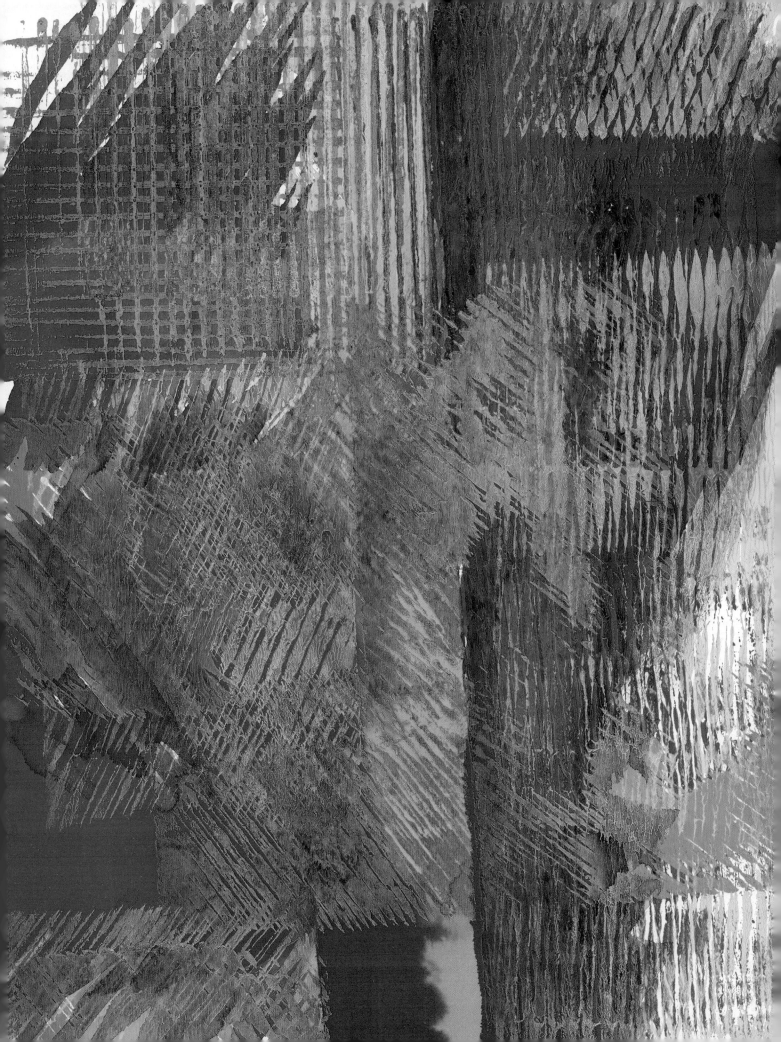

Left: Block and roller print
using kebab-stick block,
printed with acrylic then
inked.

Right: Developing print
ideas using cut print block
– roller and blockprinted
with acrylic and overinked.

DRAWING SHAPES

Do not be intimidated by the idea of drawing designs 'from scratch'. Look at favourite books of photographs, drawings and paintings, or flip through wallpaper patterns or floral designs. These can give you ideas and useful starting points. Just begin by doodling – think of it as a warm-up exercise to get the hand moving fluidly. Do not expect to be able to draw exactly what you want first time. Instead, let the pen or pencil move freely across the page, building numerous patterns that relate to your chosen theme.

Ideas for Simple Drawings

There are many ways to experiment with drawing. For example, simply doodle away using a fine black pen and outline the shapes that you particularly like. Just keep drawing over the shapes until you create the type of image that you want. Do not worry that the page is covered with lots of lines all over the place – you never know, they might lead to new ideas.

Lay a soft pastel on its side and draw with this soft edge. You will create a broad shape that you can later add to, refining lines to create a specific shape. Or load a 2.5cm (1in) brush with acrylic colour and simply paint the shapes you want to use, again and again. Once the acrylic is dry, draw into it with a coloured pencil and define the shapes that you like from your painting. Alternatively, rub a sheet of paper with charcoal, then take an eraser and draw into the dark surface with it; this will bring out yet another design idea.

If you enjoy using a computer, you could use one of the illustration or image manipulation programmes (such as Paintshop or Photoshop) to develop ideas further, and then print them out. Whatever method you use, you may find some drawings are rather small. Photocopy them and enlarge them by 50 or even 100 per cent – it is amazing how powerful they can look. Once you have a collection of shapes from any of these methods, begin to collect them together on a fresh sheet of paper. These shapes can be drawn, traced, photocopied, cut and glued to begin to make a design. It does not matter what method you use, do not worry about getting it 'wrong' and enjoy placing different design ideas together.

USING CUT SHAPES

Drawing designs using a pen or pencil can be very time-consuming, and sometimes a quicker method can be a good way of generating different kinds of designs. Using wet media can for some be a more familiar – and faster – way of exploring images, and using simple printing techniques can be liberating in helping you investigate colours and differing versions of one pattern.

Above: Fine black pen drawing outlining shapes and exploring design and pattern ideas in a sketchbook.

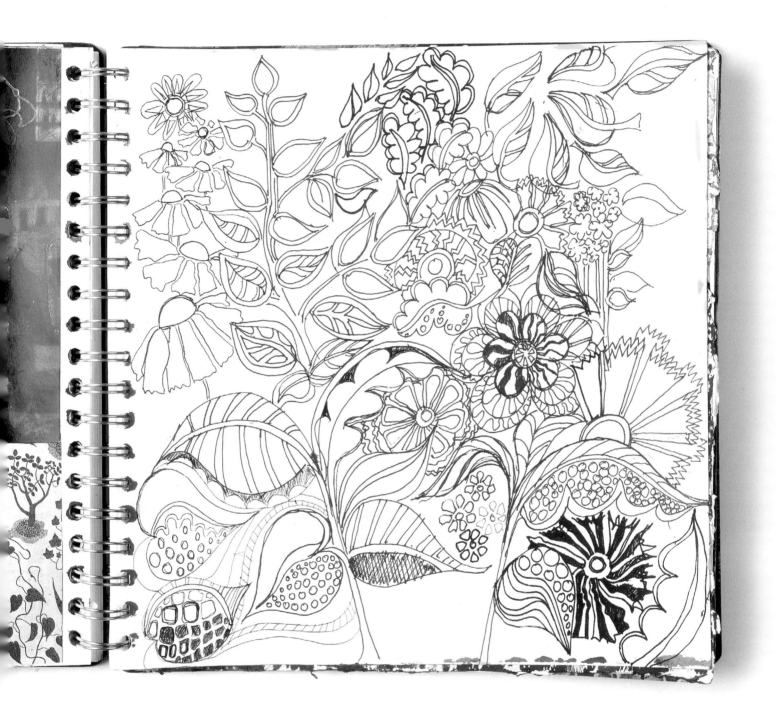

But for many people, drawing shapes for stencils or block designs is particularly difficult – the frustration of not being able to get the pencil to go where you want is rather dispiriting. In this case a cut-paper design, made using scissors, a craft knife or even by tearing paper, is a much easier and quicker method; an initial starting point can very quickly lead to making print blocks, as well as a variety of further ideas.

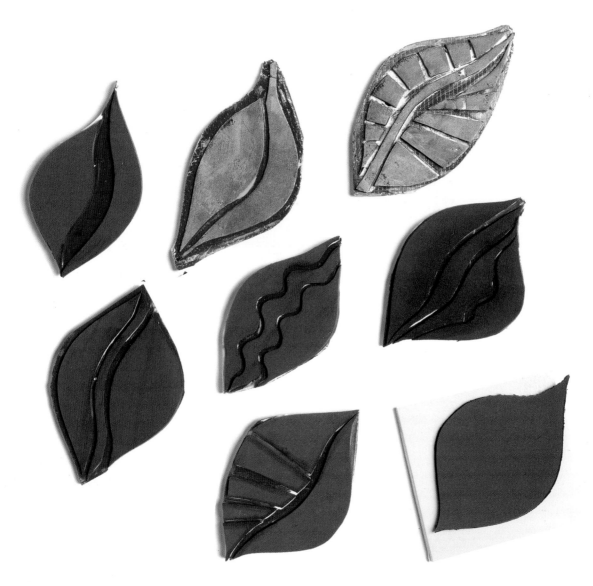

A Simple Leaf Design

When exploring cut-paper design, it is important to select a good-quality coloured paper. Start out with a simple design idea or theme – for instance, 'leaves'. Use smooth, flowing lines to draw, in this case, a simple leaf shape – keep it large, you can always reduce it in size later. Now cut the leaf out and trace around it a number of times onto different coloured sheets of paper, so that you have a collection of different-coloured leaves. Cut them out.

Next, take one leaf and cut it in half longitudinally, between the point and the stalk – the line you cut might curve or be very straight. Glue the two halves down onto a sheet of paper of a contrasting colour, arranging them together in the leaf shape but with a space between them. Now cut another leaf into half, and further divide one half of this leaf into vertical sections. Glue the pieces down on a sheet of contrasting paper, keeping a leaf shape but with space between the pieces. Try different arrangements on this 'cut and paste' theme, subdividing the leaf shapes in a variety of ways until you have a collection of leaf ideas.

Above: Simple leaf-design blocks.

Above right: Prints from leaf blocks enhanced with varnishes and inks, cut and presented on printed surfaces.

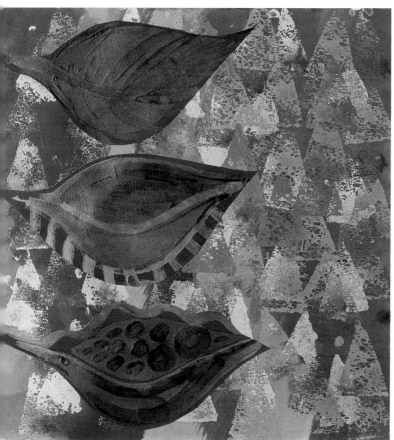
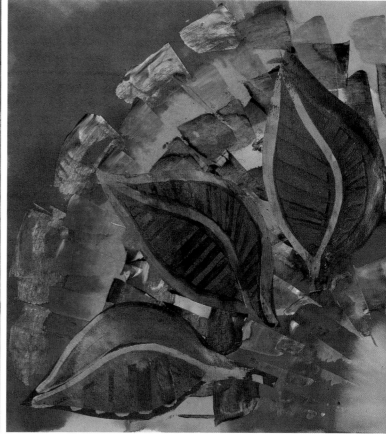

Converting Cut-Paper Ideas to Print Blocks

Once you have experimented with cut-paper ideas, you can turn them into print blocks
that you can use. Prepare some pieces of foamcore board with double-sided carpet tape. In
this case continuing with the same idea, cut a leaf shape from Foamtastic or Funky Foam
and prepare a series of blocks using some of the ideas developed with the cut paper designs.
The foam can be cut with scissors or a craft knife but unfortunately it is not possible to tear
it like paper.

At this stage you may want to make the leaf smaller, or you may wish to create a block
that has a number of leaves. Play around with the spacing of the leaf shapes but, now that
you are designing a block, remember that the background – the negative space that you will
cut out – is an important consideration.

Having prepared some leaf blocks using Foamtastic or Funky Foam, remember to
lightly coat them with white acrylic and leave them to dry before printing. Finally, consider
preparing a string block to use in conjunction with the leaf-design block.

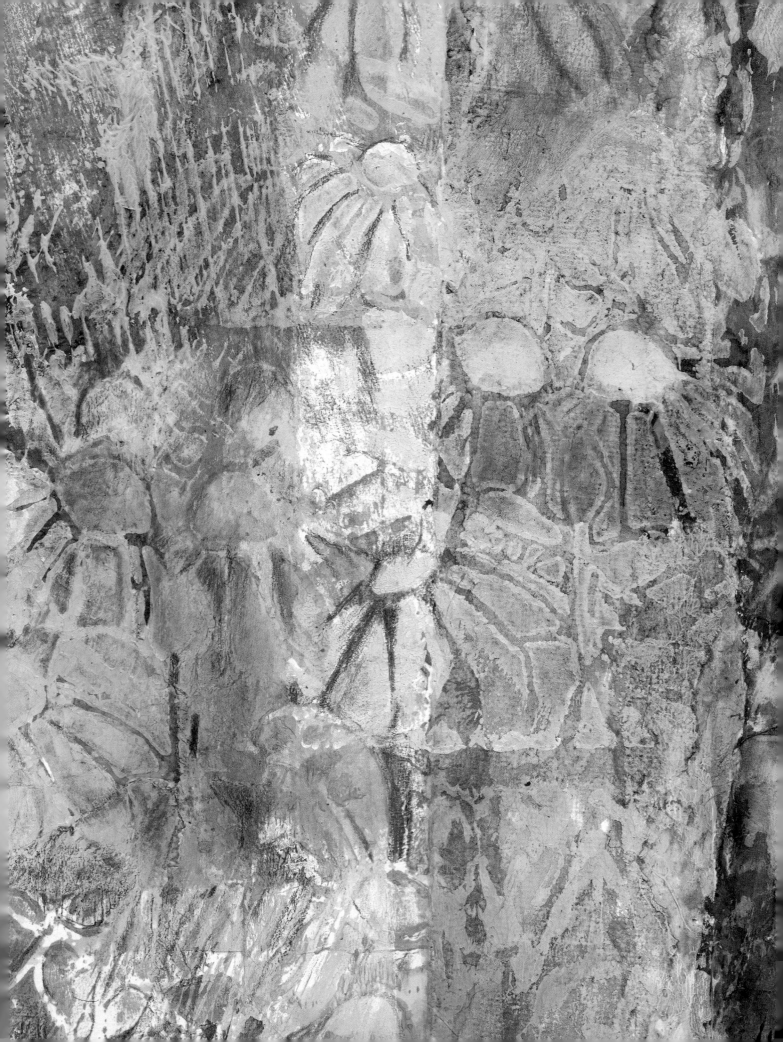

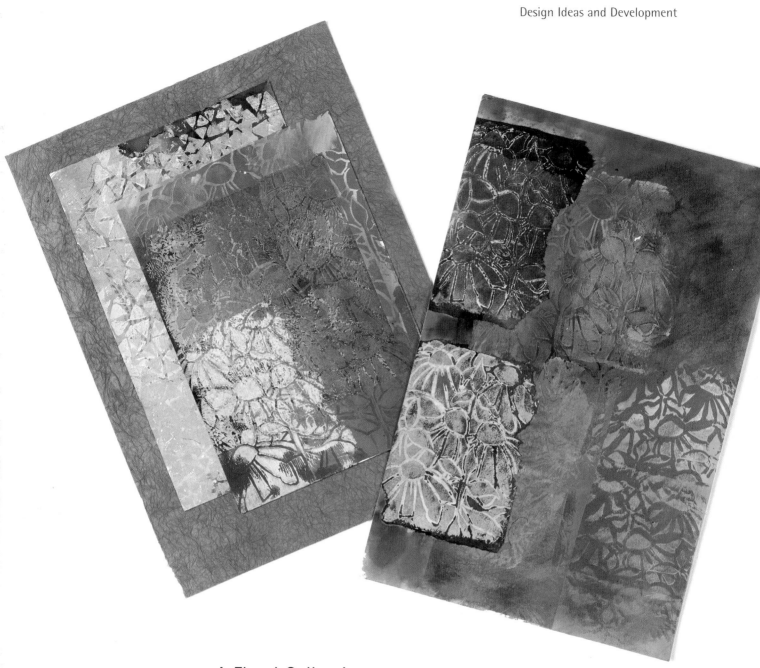

A Floral Collection

Left: Collage of different handmade and cartridge papers roller- and block-printed with acrylics, overinked with added graphite and coloured-pencil detail.

Here is another example of how I have developed design ideas in my own work. It provides a summary of many of the design ideas I introduced throughout the book. For instance, I used colours on printing sheets to create 'organic' patterns of ferns and sunbursts, and blocks in different combinations, and with different techniques.

This collection of floral prints began with an enthusiasm for making collages of summer flowers. I chose to use a wide range of printed and dyed papers that seemed to illustrate the quality and colour of the flowers and foliage. Using collage seemed so natural, tearing paper and gradually building the flowers and leaves by gluing and adding areas of colour. From these collages I made not only a design but a simple print-block cut, and developed ideas for a whole series of floral and foliage designs.

Above: Composite prints using a series of block and roller prints.

Once you have a design theme, in this case floral and foliage patterns, it is time to do some research. Time spent looking through books of traditional printed fabric designs

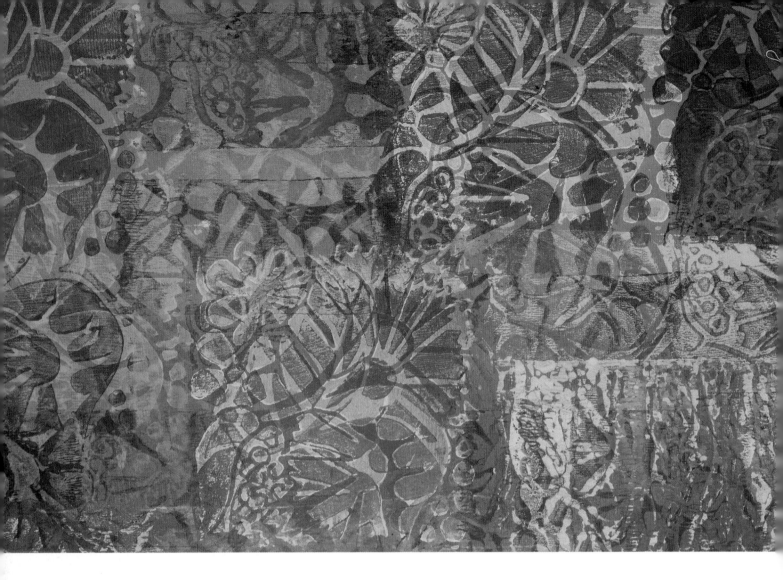

makes me aware of how many patterns can be developed from a floral and foliage source. And there are many floral and foliage designs within geometric patterns, in classical architecture, and both realistic and abstract representations. Depictions range from the pictorial and sinuous designs of the Art Nouveau period, to the combination of geometry and stylized flowers of Art Deco and the 1920s, followed by the bold outlines and cross-hatching of the 1950s and the strong, bright, simplistic flowers of the 1960s and '70s. In the 20th century alone there is a huge range of design style, scale and pattern, not to mention all the traditional designs of batik artists, hand printers, weavers and carpet makers.

Once I had some drawn ideas I used them to design and then make a cut print block (as described in chapter 2 on page 26).

There are just so many ways to use a simple block to develop a design and explore possibilities for future fabric printing ideas, some of which I described earlier (see Building a Collection from Simple Blocks, page 98). I used many in developing this floral collection, for example using sequential colours – that is, starting from white, adding yellow, adding red, adding magenta and finally violet – or printing the block repeatedly, overprinting and moving the image around.

Above: Floral print using block and roller printing. Opaque, transparent and fluorescent fabric-printing colour on dyed cotton.

Right: Exploring the possibilities once you have a collection of blocks, based on floral print work.

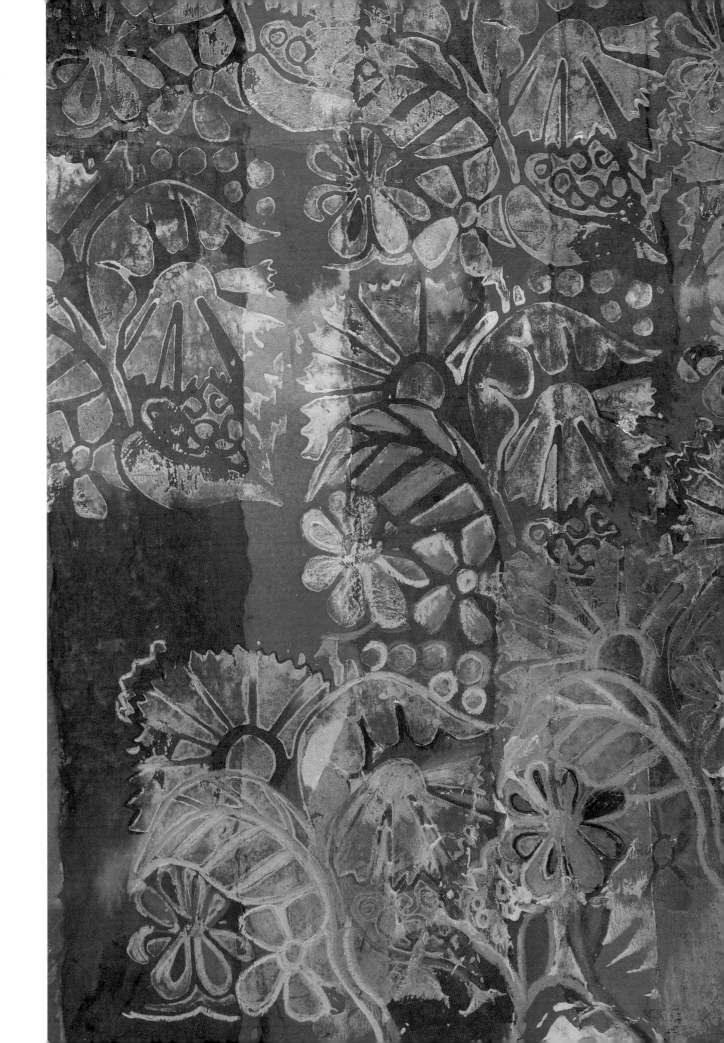

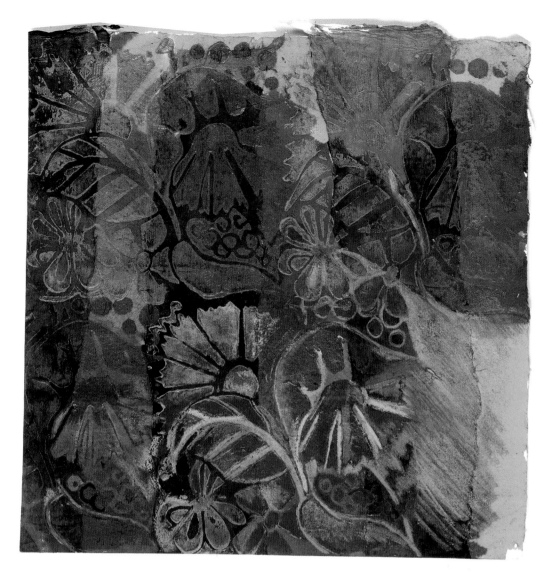

Left: Floral block print used for design development, block and roller printed in red and blue acrylic.

Below left: Development of a series of flower prints – block and roller prints in blues and greens on orange backgrounds.

Right and below: Floral block print, printed with yellow and orange onto collaged papers, then inked and further enhanced with coloured pencil.

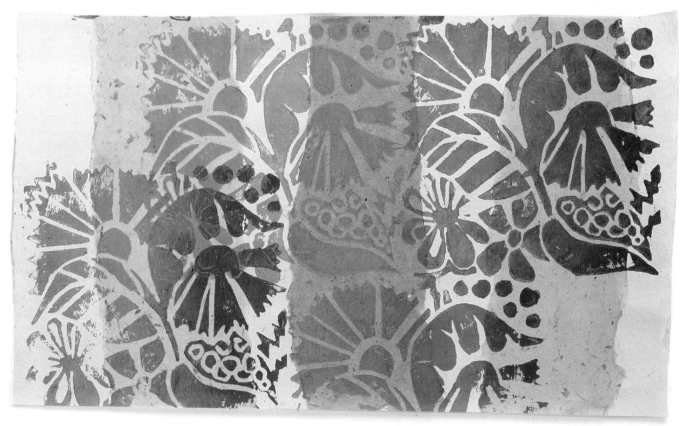

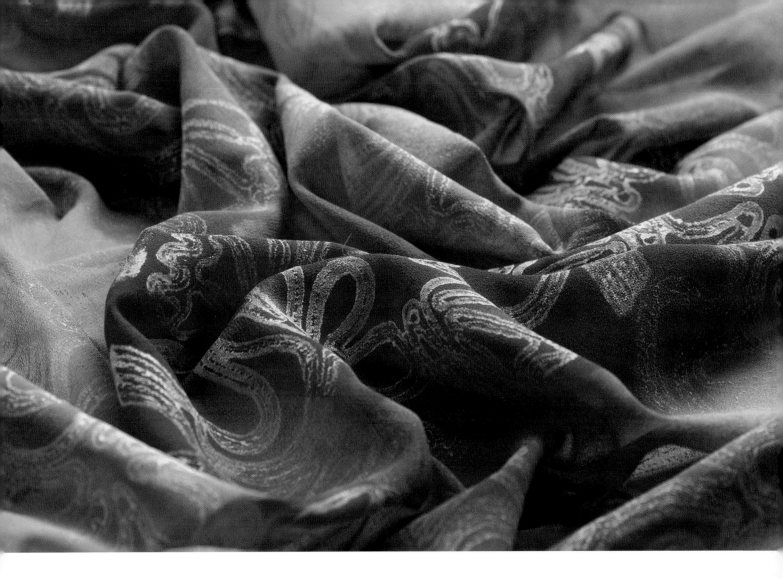

COLLECTING AND ORGANIZING DESIGN IDEAS

Once you begin thinking about design and exploring ideas of your own, you will soon find that you have collected all kinds of sketches, clippings and design notes. These can be very useful in planning future designs, but are no good if they are just stuffed into a drawer or lying around in disordered piles. You need to collate them together, finding a way to organize them that will help direct your attention to the images or information needed for your present project, or for developing your future plans. These practicalities are just as important as inspiration when it comes to developing a design portfolio.

You could keep your sketches and ideas in a series of sketchbooks, perhaps ordered by themes or mediums, or on a series of design boards or storyboards, or simply pinned up on the wall. If you pin ideas onto a board you have the advantage of being able to stand back from them, viewing them from a distance – this can help you become familiar with your own visual ideas. But if you prefer you could store your work in a portfolio, or file it in boxes or cartons. Even a well-ordered drawer can be sufficient, if you are sure you know where to find things. Whatever way you choose, it is important to try to keep your 'ideas collection' together, so that you can easily see what you have achieved, and perhaps review which way you are going, or would like to go.

Your collection of design materials should be packed with ideas and influences and buzzing with pattern, drawing, colour and texture – not only your own experiments but

Above: String block with textile colour on dyed silk chiffon.

Above right: String block on dyed viscose satin.

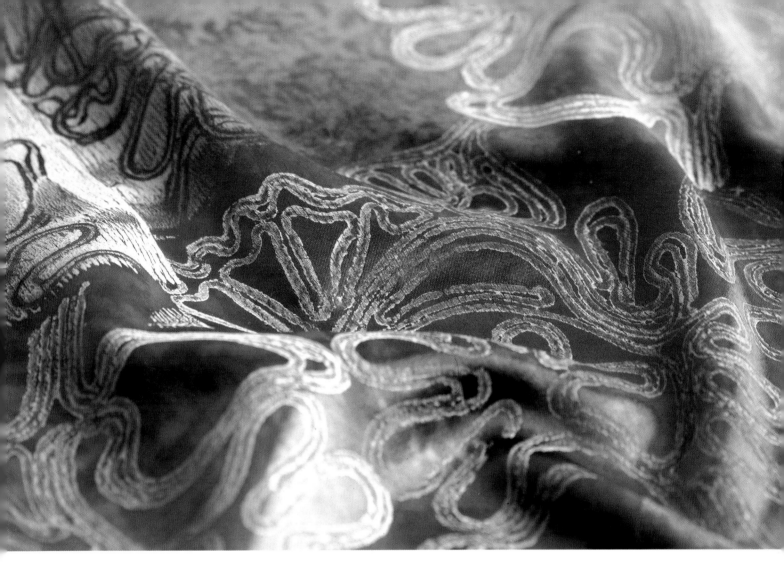

also photographs, patterns and designs from other sources. Include selections of colour that you like, drawings or torn paper ideas for shapes, patterns and arrangements.

Making a storyboard or sketchbook collection will take time and can be very satisfying in its own right. It is great fun collecting pictures, postcards, images and colour schemes together. But although it may be enjoyable to keep collecting inspiring images, it takes discipline to organize, and actually start using, these vital visual resources.

The first process is to start selecting. Sorting, looking, studying, discarding and choosing are all part of this process. Often the collection can become an unwieldy and overcomplicated encumbrance. Start to select from your collection by any of the following:

- By colour – select colour schemes that you like or group together certain colour areas such as warm colours, reds and yellows or cool colours, blues and greens.
- By design – select certain type of ideas, such as geometrics, floral patterns, figurative, linear, ornate or textural.
- By style – for instance, heavily patterned, minimal, pictorial, abstracted, structured, repetitive or by textures. This kind of selection could help you to recognize the type of pattern you prefer.

However you organize your resources, the pieces that you ultimately choose should include a variety of your own ideas – doodles, drawings, simple prints – as well as photographs, magazine cuttings, found objects and other printed matter, such as tickets or catalogues. In fact, include anything that you feel relates to the idea that you want to explore.

TAKING DESIGN FURTHER

Once you have the techniques under your fingers, and a collection of personal design ideas and preferences to draw on, both paper and fabric printing and patterning becomes an exciting and creative process. The printing process itself is enjoyable and becomes part of the creative journey, leading you to reflect on exciting combinations of colour and materials. Especially when printing on fabric, you may also enjoy considering the actual purpose of the print. As a fabric print emerges you may start to wonder how best to use it – perhaps as part of a garment, or a furnishing, or a mounted image or quilt.

Sometimes the creative thoughts that come up when you are printing, or reflecting on a print idea, are difficult to grab hold of. This is where your inspirational sketchbooks or story boards will prove invaluable, and where experimenting with ideas on paper can lead to wonderful combinations for fabric. Try using coloured pencils to add colour to paper designs as well as keeping a selection of coloured papers or fabric samples to shuffle or sort. Somehow actually handling the colour, rather than looking at it, makes decisions easier. Personally I find it quite amazing how many different combinations of fabric, print media, and print technique I have collected. Then there are all the different colourways, fibre types and differing combinations. I find that, as a result of all my paper and fabric explorations, my workroom is a mass of ideas, samples and possibilities. And in the end it is always more useful to try out different processes, techniques and methods than to spend hours reading, studying and theorizing about them.

I do hope this book inspires you to explore printing, but it would be sad if you only tried to copy ideas or colour schemes. Be assured that your confidence and knowledge will grow and improve through 'having a go' – making mistakes but also enjoying the successes. There is a pleasure to be had from creating your own design, of selecting the fabric or paper, of perfecting the technique to suit your needs, of trying colourways – and finally completing the project, washing the fabric, or mounting the paper, and realising that you have produced something unique to you.

The more you work with colour, trying it in different materials – from coloured pencils, acrylic, inks and dyes to print and stitch – the more you will find that the range of different colour combinations seems endless, especially when used with a variety of processes and materials. In some situations it is necessary to use bright, bold effects, but it is just as important to be able to introduce sensitivity and subtlety to work, perhaps giving it a more long-term interest.

Building a collection of ideas or a 'body of work' can take time, but it is immensely rewarding. And as you spend time developing, selecting and finally combining ideas you will come up with more and more designs, and you will be forming your own, individual style. The process may even go on for years, but there is no harm in that at all – enjoy your adventures in developing unique designs that grow from your creative imagination and come to fruition on paper or fabric.

Above left: Floral print on cotton poplin using transparent print colour and bronze powders.

Far left: Block and roller print using opaque and transparent print colour, then overdyed.

Near left: Flower block print, block- and roller-printed repeatedly onto calico using opaque, transparent and pearl colour, then overdyed.

Following pages: Speedy Cut design block- and roller-printed repeatedly using acrylic colour then overinked on cotton rag paper.

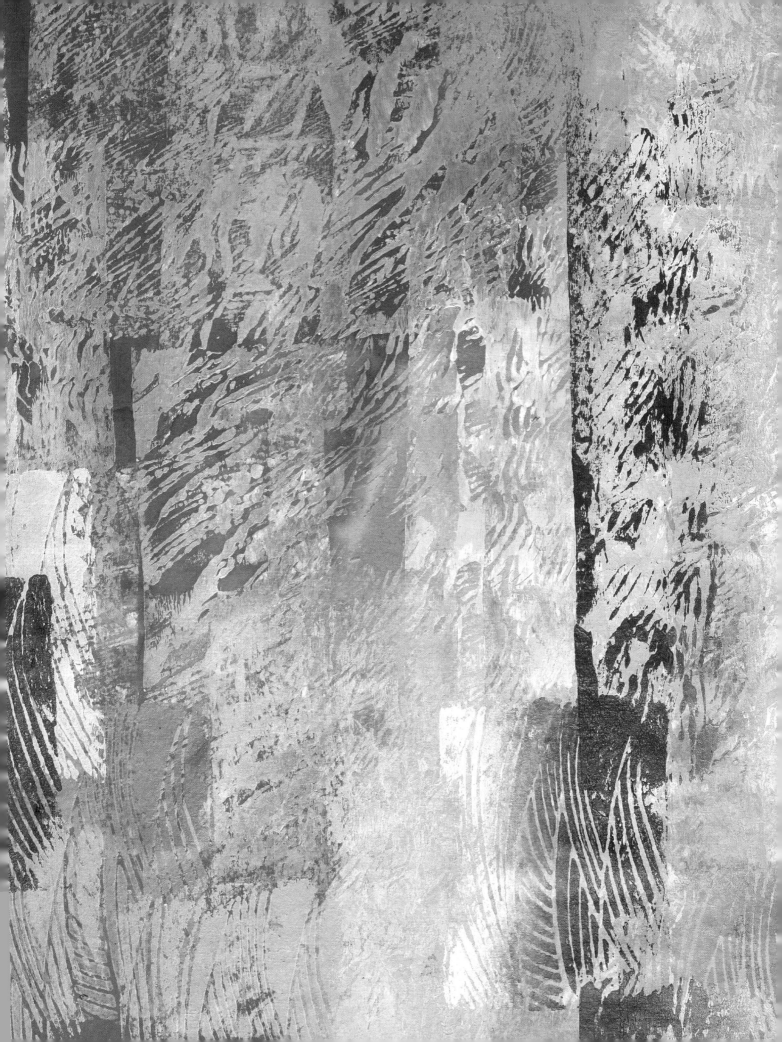

Suppliers

UNITED KINGDOM

PRINT PRODUCTS

Art Van Go
The Studios
1 Stevenage Road
Knebworth
Hertfordshire
SG3 6AN
Tel: 01438 814 946
Fax: 01438 816 267
www.artvango.co.uk
Mail order and shop. Full
range of printing equipment,
print rollers, sponge rollers,
stencils, wide range of dyes,
auxiliaries, Manutex, discharge
paste, acrylics and
sketchbooks.

**Colourcraft (Colours
& Adhesives) Ltd**
Unit 5
555 Carlisle Street East
Sheffield
South Yorkshire
S4 8DT
Tel: 0114 242 1431
Fax: 0114 243 4844
www.colourcraftltd.com
Dyes, auxiliaries, discharge
and devoré supplies, literature.

Kemtex Colours
Chorley Business
and Technology Centre
Buxton Lane
Chorley
Lancashire
PR7 6TE
Tel: 01257 230 220
Fax: 01257 230 225
www.kemtex.co.uk and
www.textiledyes.co.uk
Dyes, auxiliaries, discharge
and devoré supplies, literature.

FABRICS

Whaleys (Bradford) Ltd
Harris Court
Great Horton
Bradford
West Yorkshire
BD7 4EQ
Tel: 01274 576 718
Fax: 01274 521 309
www.whaleys-bradford.ltd.uk
Extensive range of fabrics
suitable for dyeing. Full mail-
order service.

The Silk Route
Cross Cottage
Cross Lane
Frimley Green
Surrey
GU16 6LN
Tel: 01252 835 781
www.thesilkroute.co.uk
Mail-order silk fabrics.

YARNS

Texere Yarns
College Mill
Barkerend Road
Bradford
West Yorkshire
BD1 4AU
Tel: 01274 722 191
www.texereyarns.co.uk
Wide range of undyed threads.

UNITED STATES

PRINT PRODUCTS

Jacquard Products
Rupert, Gibbon & Spider
PO Box 425
Healdsburg
CA 95448
Tel: 800 442 0455
Fax: 707 433 4906
www.jacquardproducts.com
E-mail: orders&info@jacquard
products.com
Dyes, discharge paste, fibre
etch, auxiliaries, potato
dextrin, fabrics.

Dharma Trading Company
Box 150916
San Rafael
CA 94915
Tel: 800 542 5227
www.dharmatrading.com
E-mail:
catalog@dharmatrading.com
Dyes, auxiliaries, fabrics.

FABRICS

Thai Silks
252F State Street
Los Altos
CA 94022
Tel: 800 722 7455
Fax: 650 948 3426
www.thaisilks.com
E-mail: thaisilk@pacbell.net

Test Fabrics
PO Box 26
415 Delaware Avenue
West Pittston, PA 18643
Tel: 570 603 0432
Fax: 570 603 0433
www.testfabrics.com
E-mail: testfabric@aol.com

CANADA

Maiwa Handprints
6–1666 Johnston Street
Granville Island
Vancouver
BC V6H 2SZ
Tel 604 669 3939
Fax: 604 669 0609
www.maiwa.com

G&S Dye
250 Dundas Street W, Unit 8
Toronto, Ontario
M5T 2ZS
Tel: 800 596 0550
Fax: 800 596 0493
www.gsdye.com

Further Reading

Bell, Cressida and Mackenzie, Nadia (1996). *The Decorative Painter: Painted Projects for Walls, Furniture and Fabrics.* London: Conran Octopus

Cole, Drusilla (2003). *1000 Patterns.* London: A&C Black.

Gillow, John and Sentance, Bryan (2004). *World Textiles: A Visual Guide to Traditional Techniques.* London: Thames and Hudson Ltd.

Greenlees, Kay (2005). *Creating Sketchbooks for Embroiderers and Textile Artists.* London: Batsford.

Issett, Ruth (2004). *Colour on Cloth: Create Stunning Effects with Dye on Fabric.* London: Batsford.

Issett, Ruth (1999). *Colour on Paper and Fabric.* London: Batsford.

Issett, Ruth (2001). *Glorious Papers: Techniques for Applying Colour to Paper.* London: Batsford.

Messent, Jan (1992). *Designing with Pattern.* Morecambe: Crochet Design.

Morgan, Leslie and Benn, Claire (2005). *Breakdown Printing: New Dimensions for Texture and Colour.* Betchworth: Committed to Cloth.

Parker, Julie (1998). *All About Cotton: A Fabric Dictionary and Swatchbook.* Seattle: Rain City Publishing.

Parker, Julie (1993). *All About Silk: A Fabric Dictionary and Swatchbook.* Seattle: Rain City Publishing.

Index